IMAGES
of America

EARLY
HOLLYWOOD

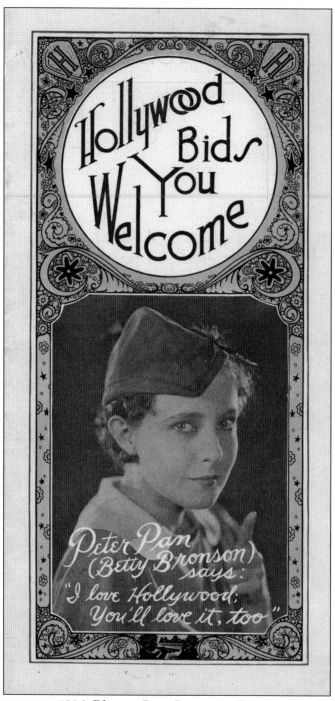

HOLLYWOOD BROCHURE, 1926. Film star Betty Bronson as Peter Pan says, "I love Hollywood; You'll love it, too," in this Hollywood Chamber of Commerce brochure.

ON THE COVER: Located on the northwest corner of Hollywood Boulevard and Highland Avenue, the Hollywood Hotel, pictured in 1903, became an iconic landmark in the center of Hollywood at the mouth of the Cahuenga Pass. (Bison Archives.)

IMAGES
of America

EARLY
HOLLYWOOD

Marc Wanamaker and
Robert W. Nudelman

ARCADIA
PUBLISHING

Published by Arcadia Publishing
Charleston SC, Chicago IL, Portsmouth NH, San Francisco CA

Printed in the United States of America

Library of Congress Catalog Card Number: 2007926150

For all general information contact Arcadia Publishing at:
Telephone 843-853-2070
Fax 843-853-0044
E-mail sales@arcadiapublishing.com
For customer service and orders:
Toll-Free 1-888-313-2665

Visit us on the Internet at www.arcadiapublishing.com

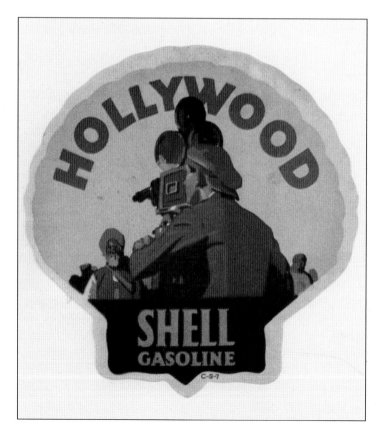

HOLLYWOOD SHELL GASOLINE DECAL, 1930s. The Shell Oil Company, like other businesses in the Hollywood area, catered to the tourist trade, which was of great economic importance.

CONTENTS

ACKNOWLEDGMENTS

This volume combines information and photographs from both Bison Archives and the Hollywood Heritage Museum. Other photographic contributors to this volume are Delmar and Antoinette Watson and Gregory and Dino Williams.

Marc Wanamaker created Bison Archives in 1971 during research for an encyclopedic history of American movie studios. The archive has been compiled from studio photographs and research materials collected since 1970. Wanamaker joined Hollywood Heritage in 1983 when the Lasky/DeMille Barn was acquired to be preserved and reopened as a Hollywood museum. After the devastating fire at the Hollywood Library, the Hollywood Heritage Museum Archive began to acquire museum-quality artifacts and materials for research and study. The "Barn" was moved to its current site at the end of 1983 and opened on December 13, 1985, with a small but important collection. By 1996, the museum's archive numbered about 500 items. After a September 1996 arsonous fire, the museum took a new approach under Robert W. Nudelman, locating and acquiring materials related to Hollywood community history, early filmmaking, and Paramount Pictures, which started in the Barn in 1913 with its rental by Cecil B. DeMille, Jesse L. Lasky, and Samuel Goldfish (later Goldwyn). Within 10 years, over 12,000 items were in the archive—preserved and catalogued, for museum displays and research. The foremost collection of its kind in the world today, it has been used for the preservation and documentation of Hollywood landmarks, including Grauman's Chinese Theater, and for films, television programs, and publications.

The Hollywood Heritage Museum Archive has benefited through the generosity of friends and strangers. Thanks goes to the following people at Hollywood Heritage: Richard Adkins, Robert S. Birchard, John Clifford, Phil Dockter, Marian Gibbons, Randy Haberkamp, Christy McAvoy, Fran Offenhauser, Marvin Paige, Arnold Schwartzman, Thad Smith, Eric Stogo, Kay Tornborg, Delmar Watson, and Valerie Yaros. Major support has come from Jaime Rigler, Cecilia DeMille Presley, Charlton Heston, Sharon and Ray Courts, Paramount Pictures, 20th Century Fox Studios, the Lot, History for Hire, Mann Theaters, Hollywood Pantages Theater, Claire Bradford, Veronica Chavez, Jim Craig, Catherine Patterson Davis, Johnny Grant and the Hollywood Historic Trust, Amy Higgins, Eugene L. Hilchey, Betty Lasky, Julian "Bud" Lesser, Grant Loucks, Portland Mason, Ruth and Sol Nudelman, Rica and Randy Van Ausdell, Ken Annakin, Pat Hitchcock, Carla Laemmle, Janet Leigh, Ronald Neame, David Raksin, Leonard Rosenman, Ann Savage, Jan Sterling, Rod Taylor, Henry Wilcoxon, Jonathan Winters, Robert Wise, and Michael York.

INTRODUCTION

This volume is the first of two and begins with the Hollywood area from the 1880s to 1940. The volumes contain an overview of the history of Hollywood with illustrations. The area of what is now Hollywood was once a part of the overall province of Spanish California that was claimed in the 16th century. The semi-arid landscape was surrounded by hills and mountains where the Native Americans lived for centuries before white settlers arrived. Since the area of Los Angeles was first explored in 1769 to the founding of Hollywood in 1903 and well into the early 20th century, Hollywood was considered only a suburb of Los Angeles.

Hollywood occupies five miles of foothills along the eastern curve of the Santa Monica Mountains. Cahuenga Pass is at the center of the Hollywood area and has always connected the San Fernando Valley with the Los Angeles basin, leading south to the original Pueblo of Los Angeles. The Hollywood vicinity for thousands of years has been a semi-arid desert environment with scrub brush with a few oak trees in the foothills. The first people in the area were the Shoshone tribe, named Gabrieleno by the Spanish, who lived along the inland mountains from Laguna Beach to Malibu. The main trading village was supposed to be located at what is now the north side of the Cahuenga Pass where Universal Studios is today. The village's name was Cabueng-na, which later was changed into the Spanish translation Cahuenga in 1769. El Camino Real was the Spanish trail that passed through the area leading up the coast of California where Fr. Junipero Serra established the mission system in California. In 1781, during the reign of King Carlos III, a small group of settlers established the Pueblo of Los Angeles, El Pueblo de la Reyna de Los Angeles, at an encampment alongside the Los Angeles River near where Union Station is today. Because of floods, the pueblo was moved to what is now the Los Angeles Plaza area. The pueblo remained an outpost of New Spain until 1821, when Mexico broke away and established a new, independent nation. The old Spanish realm of California, including the city of Los Angeles, became a colony of Mexico. The Mexican government designated Los Angeles a city in 1835. The Mexican phase—known as the rancho period—lasted until the end of the Mexican War, from 1846 to 1847.

King Charles III of Spain granted large sections of this land to the various families that settled the land on behalf of New Spain. These parcels of land were called "ranchos," and the first of the settlers to be granted the area of the Cahuengas was the Moreno family. Before its full independence of 1821, Mexico claimed the land of the Cahuengas, and the area's first subdivisions were born as Rancho Los Feliz and Rancho La Brea, which divided the Hollywood area. The north side of the Cahuenga Pass was the site of a number of minor skirmishes that were significant in California history. War was declared in 1846 between the United States and Mexico, whose weak government controlled California. Gen. Andres Pico surrendered to the United States within a year, signing the Treaty of Cahuenga on January 13, 1847, at the Casa de Adobe de Cahuengas, which once stood across from what is now Universal City on Lankershim Boulevard. With the 1848 Gold Rush came thousands of settlers to Northern California, and by 1850, California became the 31st state in the Union, with an ever-growing population.

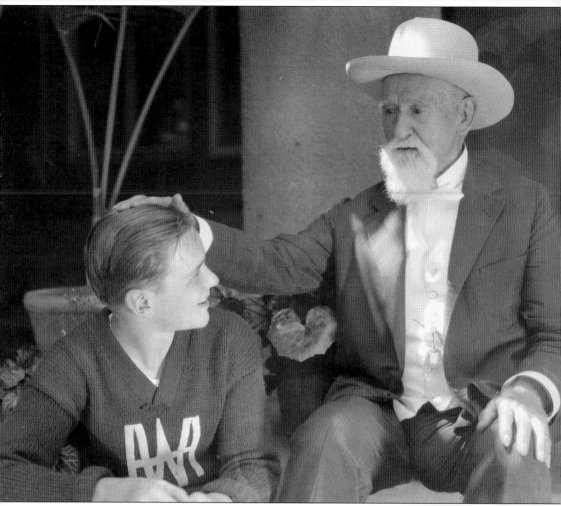

RANCHO GENERATION MEETS THE 20TH-CENTURY GENERATION, 1923. Hollywood pioneer Sen. Cornelius Cole meets with 14-year-old Douglas Fairbanks Jr. at his residence at Colegrove farm at the southeast corner of Lexington Avenue and Lodi Place during publicity outings for Fairbanks's new Paramount film, *Stephen Steps Out*. Cole came to California in 1849, became a U.S. Senator, and settled in Hollywood in 1881.

One

THE POST-RANCHO PERIOD

The old rancho era in Southern California was being transformed in the 1880s, mostly by Anglo entrepreneurs, and Los Angeles was amid a real estate boom. Where the old El Camino Real passed through Cahuenga Pass, the Ranchos Los Feliz and La Brea met at a crossroads of commerce between Los Angeles and the San Fernando Valley. The first prominent Rancho La Brea resident was James Thompson, who built an adobe house and corrals after obtaining a five-year lease in 1852 at what is now the Farmers Market at Fairfax Avenue and Third Street. The property later became part of Henry Hancock's tract, centered at Wilshire Boulevard and Fairfax Avenue, which included the La Brea Tar Pits. In 1885, the Hancocks struck oil with great success. Near the century's end, Arthur Gilmore established a dairy farm within Rancho La Brea. In 1903, while drilling for water, Gilmore struck oil and later established the A. F. Gilmore Oil Company on the site of the present-day Farmers Market and CBS Television City. Jose Vincente Feliz, who became one of Los Angeles' first city administrators, owned rancho Los Feliz.

The rancho lands were located in the future Hollywood area, including the mouth of the Cahuenga Pass. In 1882, Col. Griffith J. Griffith purchased a large tract in the Hollywood foothills. Other settlers bought and subdivided Los Feliz lands. Wooden buildings with porches replaced adobes, and wells, windmills, and gardens brought a Midwestern look to the old ranchos. Farmer John T. Gower purchased lands between Sunset Boulevard and Melrose Avenue and from Bronson to Gower Streets. By 1875, the Gowers owned over 400 acres. Another early farmer was Jacob Miller, who purchased land at the mouth of Laurel Canyon. In 1885, the J. B. Rapp family took over 40 acres at the mouth of Beachwood Canyon, off Franklin Avenue. Dennis and Margaret Sullivan homesteaded a section of land west of Vermont Avenue near Sunset Boulevard. These farmers raised wheat, pineapples, dates, tomatoes, beans, oranges, lemons, avocados, garden vegetables, and grapes.

By 1900, Los Angeles was mostly farmland with a growing economy helped by the crisscrossing of the Pacific Electric Red and other trolley cars and Southern Pacific freight lines. This transportation brought the first tourists.

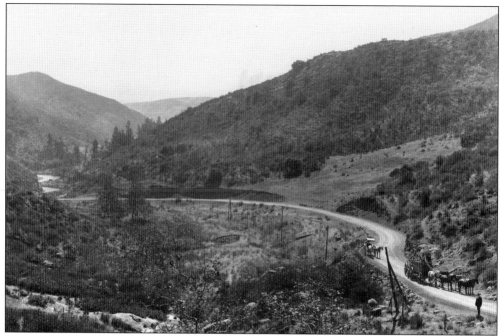

CAHUENGA PASS, 1889. Looking south along Pass Road, which was later named Cahuenga Boulevard West, the Cahuenga Pass was a dirt road parallel to the Cahuenga Arroyo. This was the main access to the San Fernando Valley, and for thousands of years, the Native Americans used the pass and settled in its small canyons until the early 1900s.

FRANKLIN AND BRONSON AVENUES, 1890. Hollywood in the 19th century was a rural farming community located in a semi-arid environment, constantly needing water to irrigate the many fields growing diverse crops, from vegetables to citrus.

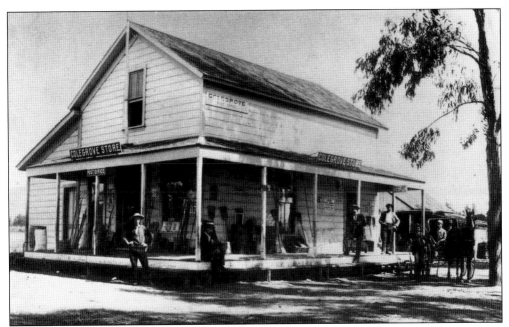

HOLLYWOOD POST OFFICE, 1892. The first area post office was housed in the Colegrove Store on the northeast corner of Santa Monica Boulevard and Vine Street. Established in 1888, the store was the only place for miles around to buy supplies.

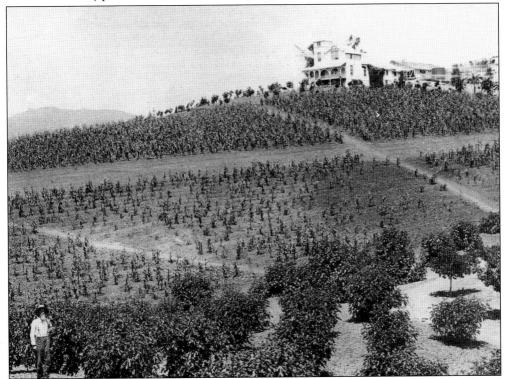

KROTONA HILL, 1893. The Krotona farm, located on what are now the foothills of north Gower Street near Beachwood Drive, was one of several farms growing corn and citrus products.

OLIVE HILL, 1895. Hollywood in the late 19th century was a semi-arid landscape with farms dotting the countryside, which was devoid of trees and always in need of water. This is a view from what is now Barnsdall Park looking north with the later-named Hollywood Boulevard at the bottom left, Franklin Avenue in the center, and Los Feliz Boulevard in the foothills.

EAST HOLLYWOOD, 1895. A group of children pose near the corner of Sunset Boulevard and Western Avenue. Large houses, such as this one, were located south of Sunset on large farms that dominated the area until the 1920s. The farms south of Sunset later became the site of the William Fox Studios in 1915.

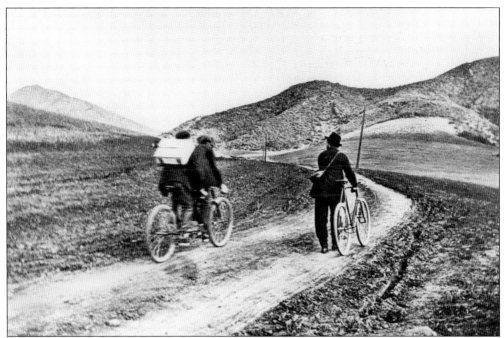

CAHUENGA VALLEY AVENUE, 1897. Bicyclists make their way on Pass Road into the mouth of the Cahuenga Pass near what is now Whitley Avenue. This was the traditional way into the San Fernando Valley along the old El Camino Real, which was originally a Native American pathway.

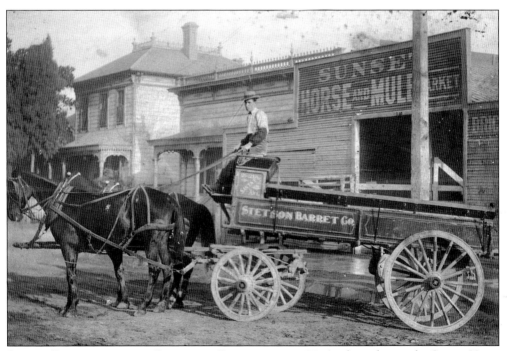

SUNSET BOULEVARD NEAR CAHUENGA BOULEVARD, 1887. At the right are the Sunset Horse and Mule Market building and a brick distributing company next door. The wagon pictured is from the Stetson Barret Company at Santa Fe Avenue in downtown Los Angeles.

BEACHWOOD CANYON, 1897. The main house of the Henry Claussen Farm was situated on a hill overlooking a dirt road that is now Beachwood Drive. The two-story structure with its galleried porch still exists and is located at 6116 Winans Drive in Beachwood Canyon. Built around 1880, the house is one of the oldest Hollywood houses and today is an apartment house.

HOLLYWOOD, 1888. This is a view of the Hollywood area from Normandie and Melrose Avenues. These lands were originally Rancho Grant territories, which dominated the area for over 200 years. Farming was the predominant economy of the area well into the 20th century, with small farms dotting the landscape in between stands of eucalyptus trees.

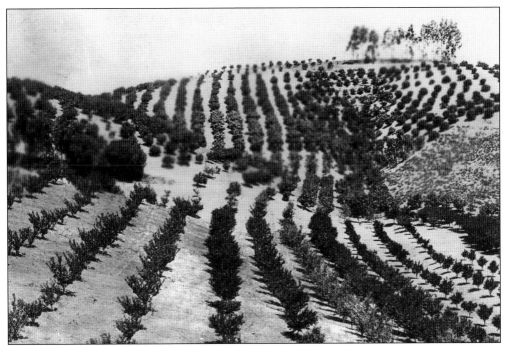

CLAUSSEN AND ROBERTS FARMS, 1880s. In the early 1870s, Henry Claussen, a German immigrant, purchased a section in lower Beachwood Canyon and raised tomatoes, melons, and peas there. His neighbor, O. E. Roberts, grew citrus crops.

CAHUENGA PASS, 1880s. The junction of Highland Avenue and Cahuenga Boulevard at the entrance to the Cahuenga Pass was known as El Camino Real during the days of the missions. The original names for the roads leading into the pass were Pass Road (Highland Avenue) and Cahuenga Valley Road (Cahuenga Boulevard). By 1902, Highland Avenue was the main thoroughfare into the San Fernando Valley.

WILCOX AVENUE, 1890s. Looking north up to what is now Wilcox just south of Prospect Avenue (later Hollywood Boulevard) was a dirt road and one of the main arteries through the citrus groves that were the main cash crop of the Hollywood area at that time.

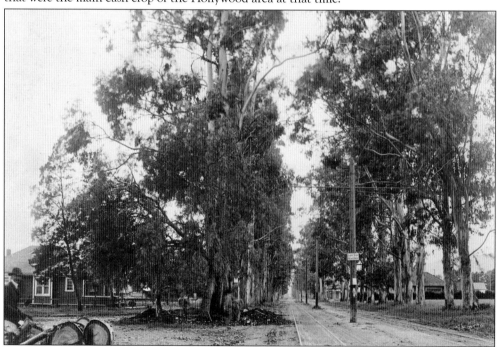

SANTA MONICA BOULEVARD, 1902. Looking west at Seward Street along the Pacific Electric rail line, this section of Hollywood became the center of various services for the motion picture studios that later dominated the economy throughout the decades. In 1919, the Jasper Hollywood Studio was built on the property to the left of the photograph between Seward Street and Las Palmas Avenue to the west.

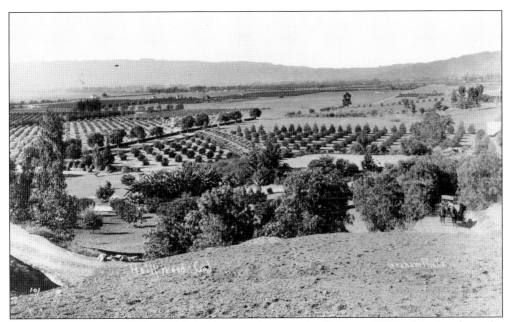

VIEW FROM LAUGHLIN PARK, 1896. Looking southwest to the Hollywood Hills, this view shows the vast farmlands that were once a part of the rancho lands of Southern California. At this time, the farms dotting the area were connected by dirt roads leading from one small village to another.

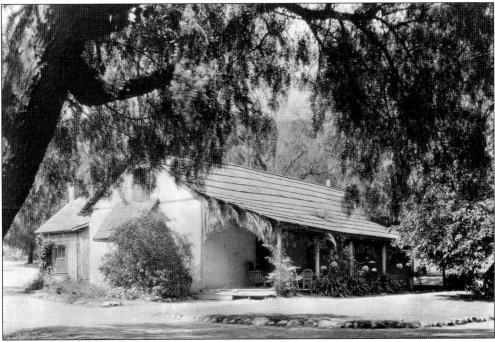

CASA DON TOMAS, 1895. The first adobe house built in the Cahuenga Valley area was built in 1853 by Don Tomas Urquidez on the northwest corner of Franklin Avenue and Sycamore Drive. Known as the "Outpost" house in later years, the house became a local landmark. Don Tomas was the first Spanish resident of Nopalera (now Hollywood), and his cattle grazed throughout the foothills at what is now Franklin Avenue to the mouth of the Cahuenga Pass.

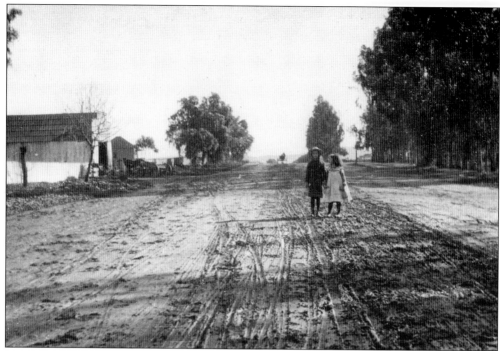

SUNSET NEAR GOWER, 1907. In this view looking east down Sunset Boulevard, children are seen walking along the wide and muddy road lined with eucalyptus and pepper trees. The first studios in Hollywood were established on these old farmlands between Vine and Gower Streets.

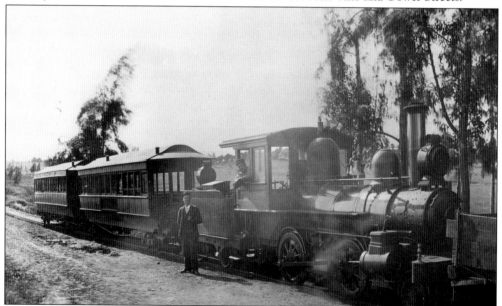

CAHUENGA VALLEY RAILROAD, 1888. E. C. Hurd and Harvey Wilcox purchased the Second Street Railway and renamed it the Cahuenga Valley Railroad with the intention of creating a rail line to Hollywood. Later they continued the line down Prospect Avenue to Highland Avenue and then to Laurel Canyon. In 1898, Col. Moses Sherman and E. P. Clark purchased the line and expanded to the newly created Sherman, California (now West Hollywood).

Two

A CITY IS BORN

Cahuenga Valley was by 1883 a small farming community at the mouth of the Cahuenga Pass, eight miles north of growing Los Angeles. Kansas businessman Harvey Wilcox bought land to subdivide and, by 1886, had purchased a 120-acre tract located in the area that is now bounded by Whitley Avenue, Sunset Boulevard, Gower Street, Prospect Avenue (Hollywood Boulevard) and Franklin Avenue to the north. It became the family's most important parcel. Wilcox's wife, Daeida, visited her old home in Ohio and, on the train back, was said to have met a woman who described her own summer home in the Chicago area as "Hollywood." Daeida liked the name so well that she convinced her husband to name their new development Hollywood.

Harvey Wilcox demarcated the development on a map filed with the Los Angeles County recorder on February 1, 1887. Harvey passed away in 1891, and Daeida managed the Wilcox holdings until she married Philo Judson Beveridge in 1894. The Beveridges had four children and became one of the most influential families in Hollywood. Other developers active in the late 1880s were Homer Laughlin, whose hillside acres east of Western Avenue and north of Franklin were developed into the exclusive residential Laughlin Park, and state senator Cornelius Cole, whose 1893 subdivision, Colegrove, was bounded by Sunset Boulevard between Seward and Gower Streets to the north and Santa Monica Boulevard to the south.

Hollywood's development was hastened in the 1880s by the construction of the Los Angeles Ostrich Farm Railway Company and the Cahuenga Valley Railroad. By 1890, Gen. Moses Sherman bought control of the Pico Street Electric Railway and expanded its service. On April 11, 1894, Sherman and his brother-in-law Eli P. Clark incorporated the Pasadena and Los Angeles Electric Railway Company, which constructed the first electric interurban line, between the railroad's title cities. By 1896, Sherman and Clark acquired other railways including the Cahuenga Valley Railroad, and, in 1898, the Los Angeles–Pacific Railroad Company.

In November 1897, the first post office opened in the Sackett Hotel. By 1895, the growing Hollywood community faced water shortages, street repairs, and a lack of schools. As a result, the Hollywood Board of Trade was formed in 1903, and a petition to the county board of supervisors requested the incorporation of the City of Hollywood. The November 14, 1903, election resulted in Hollywood being designated as a city in its own right. The city limits were Normandie Avenue on the east, Fairfax Avenue on the west, Santa Monica Mountains crest on the north, and Fountain Avenue on the south.

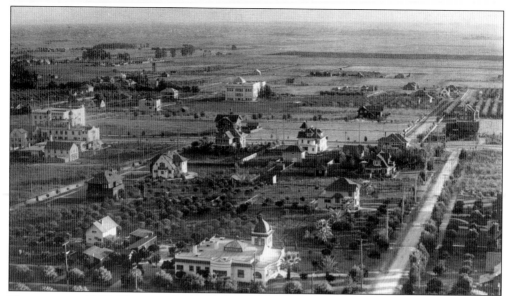

HOLLYWOOD, 1905. This view looks south above Franklin Avenue with Orange Drive to the right and Prospect Avenue at center. The Hollywood Hotel is at the far left, and Hollywood High School is the domed building in the upper center. The white house in the center on Prospect Avenue is the future site of the Grauman's Chinese Theater, and the large house at far right is where the Hollywood Roosevelt Hotel would be built. The large home with the Moorish tower at bottom center is the current home of the American Society of Cinematographers Clubhouse at Orange Drive and Franklin Avenue.

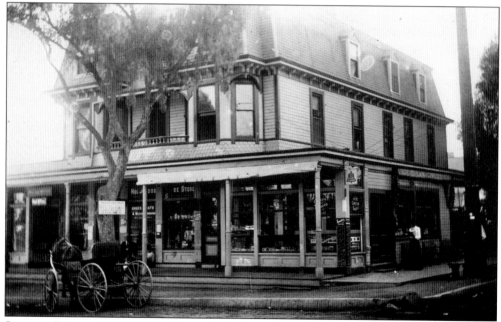

SACKETT HOTEL, 1900. Built by Horace D. Sackett in 1888, this was the first hotel in the area (18 rooms) and the second general store, located at Cahuenga and Hollywood Boulevards. In 1891, it became Hollywood's first post office, remaining as such until 1905. The building was located on the southwest corner, and a large corral and barn were built in the back for guests and neighbors.

SIX MILE HOUSE, 1897. Located at the northeast corner of Sunset Boulevard and Gower Street, across from the Blondeau Tavern, the Six Mile House was built and operated by Martin Labaig in 1887. It was typical of the establishments that dotted the route between downtown Los Angeles and the ocean, providing food and essentials to travelers. Labaig would be involved in a residential neighborhood a block north of here in the early 1910s that is still relatively intact as Labaig Avenue.

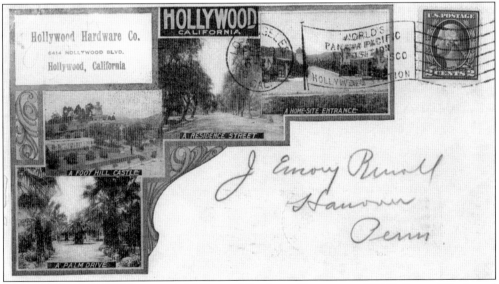

ADVERTISEMENT ENVELOPE, 1913. Hollywood Hardware Company at 6414 Hollywood Boulevard sponsored this envelope promoting the upcoming "1915 World's Panama Pacific Exposition in San Francisco." Envelope photographs show the "Foothill Castle" of Dr. Schloesser and street scenes. On the rear of the envelope is written, "Hollywood, California, 'City of Enchantment.' The High-Class suburb of Los Angeles, located next to the foothills, six miles from the center of the city . . . Magnificent mountains, gorgeous gardens, princely palaces . . . and a perfect climate . . . A leader in education . . . Hollywood's high school . . . churches, libraries, theatres and amusements . . . there is a home here for you."

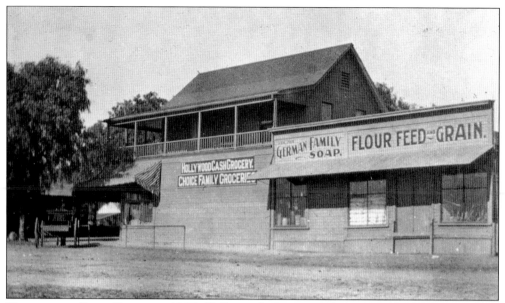

HOLLYWOOD CASH GROCERY, 1905. Hollywood's first general store was the property of John Watts, who came to Los Angeles in 1886 from England. He bought a general merchandising store in Hollywood and by 1888 purchased from Harvey Wilcox three-and-a-half acres on the northeast corner of Cahuenga and Sunset Boulevards. He moved his general store to the new location along with the postal service he had established previously. In 1895, Watts went back to England and never returned to America.

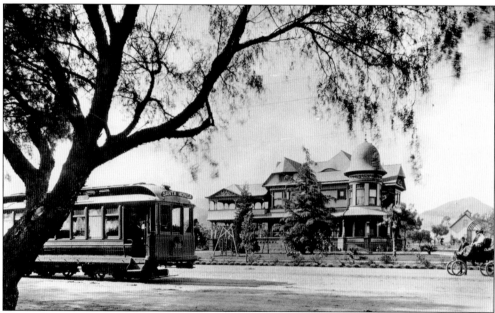

PROSPECT AND WILCOX AVENUES, 1900. The Pacific Railroad Santa Monica Line passes by the residence of E. C. Hurd on the northwest corner of Prospect and Wilcox Avenues. Around 1887, Hurd purchased the entire block of land from the Wilcox family and later purchased land south of Prospect and planted the first lemon grove in town. Hurd, a wealthy Colorado miner, helped gather investors to buy the Second Street Railway and rename it the Cahuenga Valley Railroad.

DAEIDA HARTELL WILCOX, 1887. Born in Hicksville, Ohio, in 1862, Daeida later married Harvey H. Wilcox, a real estate developer from Topeka, Kansas who brought her to California in 1883. It was Daeida who christened their 120-acre ranch "Hollywood," a name she adopted from meeting a woman on a train in 1887 when she was on her way to Ohio. The woman described her summer home in Illinois as "Hollywood." Daeida liked this name, and Harvey liked it as well; they agreed to name their subdivision Hollywood.

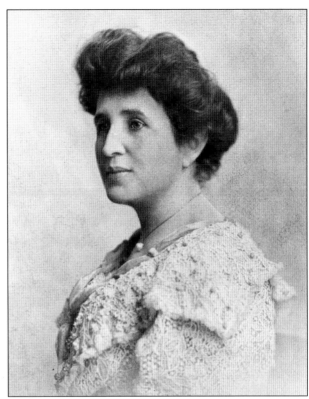

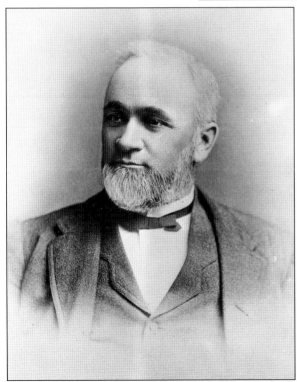

HARVEY HENDERSON WILCOX, 1887. Born in Topeka, Kansas, Wilcox, a real estate developer, brought his wife, Daeida, to California in 1883. By 1885, Wilcox had invested money in a fig ranch on a 120-acre parcel of land in the northwest sector of Los Angeles known then as the Cahuenga Valley. In 1891, Harvey Wilcox passed away, and Daeida remarried Philo J. Beveridge in 1894. It was Daeida and Harvey that named their development Hollywood.

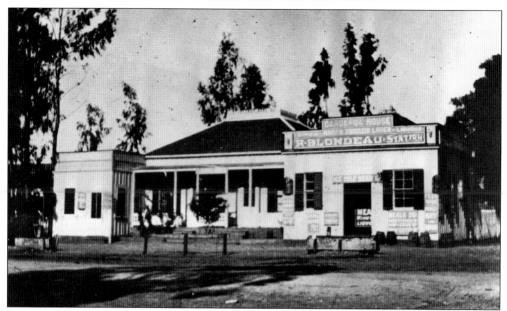

BLONDEAU TAVERN AND GENERAL STORE, 1890. On land purchased from Harvey Wilcox at the northwest corner of Sunset Boulevard and Gower Street, Rene Blondeau built a home and lived there for two years before building a roadhouse on the corner and naming it the Blondeau Tavern. Blondeau was a friend of Frenchman Martin Labaig, who purchased the property across the street on the northeast corner of Sunset and Gower in 1887 and opened Casa Cahuenga, or the Six Mile House. In 1911, the Blondeau Tavern became the site of the first motion picture studio in Hollywood.

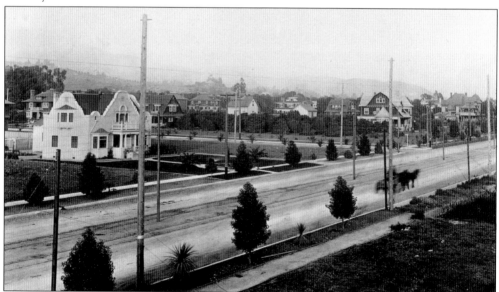

PROSPECT AVENUE, 1905. Hollywood at this time was a quiet residential community served by the Pacific Electric railways that connected Hollywood with downtown Los Angeles. Looking east toward Cherokee Avenue, the Janes sisters' residence is in the middle-right of the photograph, and the Hurd residence, the first on Prospect Avenue, at the northwest corner of Prospect and Wilcox Avenues, is seen at the far right.

HIGHLAND AVENUE, 1904. This is a southwest view from Whitley Heights with the intersection of Highland and Franklin Avenues at bottom-center. The Hollywood Hotel is seen at the far left on the northwest corner of Highland and Prospect Avenues. Orchid Avenue is in the center, and Orange Avenue is at the far right. The Grauman's Chinese Theater and the Hollywood Roosevelt Hotel were built on either side of Prospect Avenue at Orange Drive in 1927.

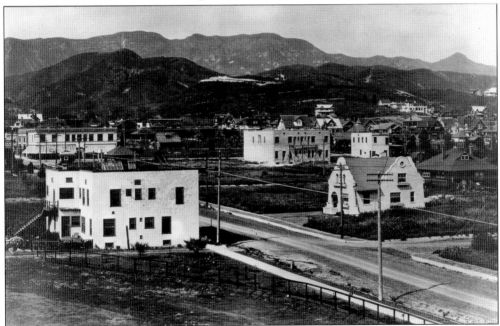

NORTH HIGHLAND AVENUE, 1907. A view of Highland Avenue from the Hollywood High School on the northwest corner of Sunset Boulevard. The northeast corner of Prospect and Highland Avenues is at the top-left of the photograph. The Whitley residence at the top of Whitley Heights can be seen in the top-center.

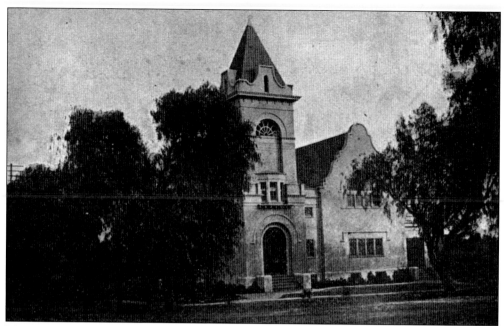

METHODIST EPISCOPAL CHURCH SOUTH, 1905. The Methodist church was established at Fairfax Avenue and Santa Monica Boulevard in 1890 and subsequently moved to Cahuenga Boulevard and Selma Avenue. In 1904, the congregation built a first-class church building on the southeast corner of Prospect Avenue and Vine Street. In 1924, the 12-story Taft Building was built on the site of the church, beginning a new and modern era for Hollywood. A new, larger Methodist church opened in 1929 at Franklin and Highland Avenues, where it remains to this day.

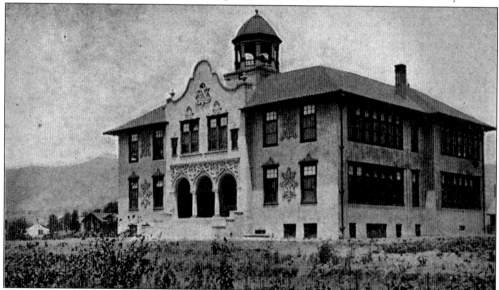

FREMONT GRAMMAR SCHOOL, 1905. When Hollywood High School was being constructed in 1904, two other schools were being built as well, forming a part of the Hollywood Union School District. Fremont Grammar School, later renamed Selma Avenue School, and Grant School were the first of three that were built. Three months after Los Angeles annexed Hollywood in 1910, the Gardner Street School was added.

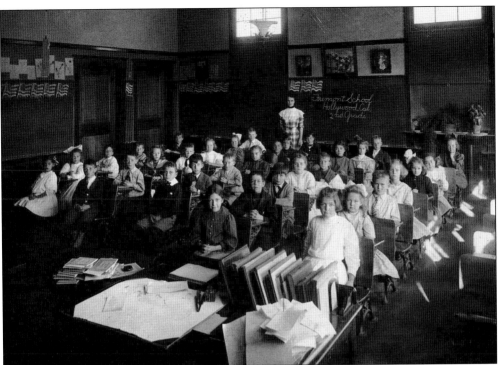

FREMONT GRAMMAR SCHOOL, 1905. Seen here is a second-grade class at the Fremont School, which was built on Selma Avenue in 1904. The children were from a mixture of farming and professional families from the Hollywood area. Note the formal and disciplined students all neatly dressed and behaved.

PROSPECT AND HIGHLAND AVENUES, 1904. This view is looking northeast from Orange Avenue with the Hollywood Hotel in the center at Highland Avenue. In the foreground are the strawberry fields that became the site of the Hollywood Roosevelt Hotel. The house at the far left is near the site of the Grauman's Chinese Theater, built in 1927.

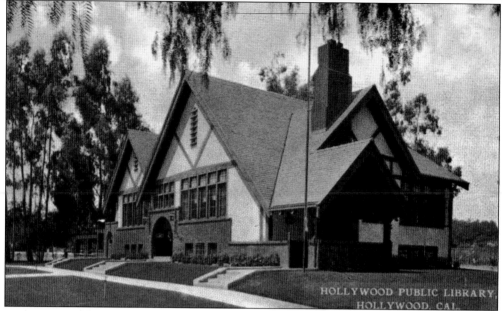

HOLLYWOOD PUBLIC LIBRARY, 1916. Located on the northwest corner of Hollywood Boulevard and Ivar Avenue, the Tudor-style library building was constructed with help from fund-raising efforts by the Hollywood Women's Club. It opened on April 1, 1907, as Hollywood's first library and remained on the site for 15 years until it was moved to another location.

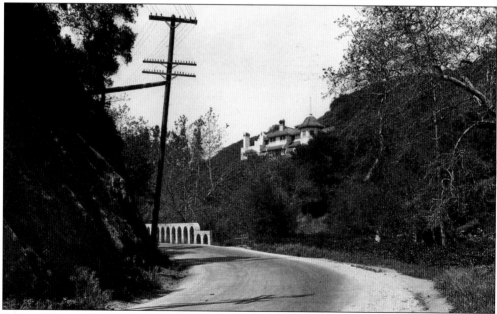

RALPH WALKER ESTATE, 1918. One of the more notable estates in Laurel Canyon was built in 1915 by pioneering Los Angeles store owner Ralph M. Walker. Walker's mansion in the Italian-villa style became a landmark in the canyon and was located at the intersection of Laurel Canyon Boulevard and Willow Glen Road. The 10-acre estate had extensive gardens and a grotto connected with waterfalls, ponds, and streams. Laurel Canyon had only begun to be developed as a country community with fine homes by 1912.

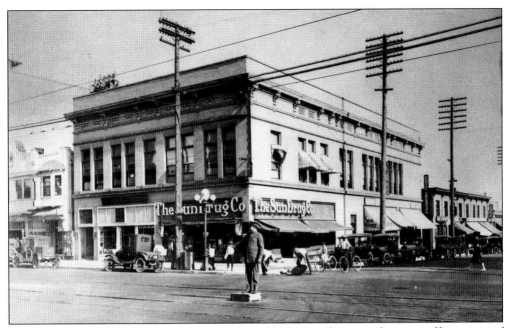

HOLLYWOOD AND CAHUENGA BOULEVARDS, 1923. A policeman directs traffic at one of Hollywood's most famous intersections. This area was at the heart of the Wilcox subdivision in 1887. On the southeast corner is the Sun Drug Company Building, which was later demolished and replaced by the Streamline Moderne–style Julian Medical Building by 1934.

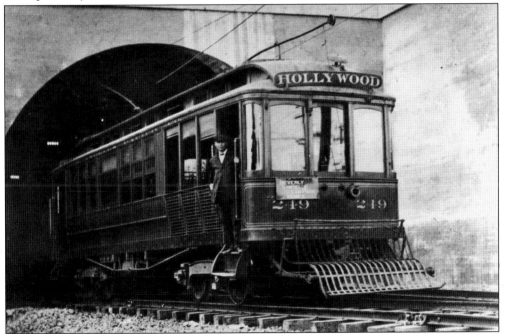

HOLLYWOOD TUNNEL DAY, 1909. S. H. Laverty stands on the steps of a Pacific Electric car on Tunnel Day. The completion of this tunnel cut 12 minutes from the time it took to travel from downtown Los Angeles to Hollywood. The tunnel opened on September 23, 1909, and was 1 mile long, allowing trolleys direct access to Hollywood proper.

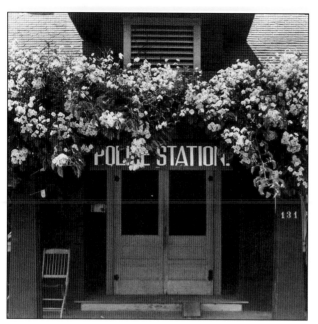

HOLLYWOOD POLICE STATION, 1910. In 1904, Hollywood's first police station was a small bungalow located at 131 Cahuenga Boulevard, south of Hollywood Boulevard near Selma Avenue. The new station housed the city clerk and city engineer as well. The early police department consisted of two officers who made house calls on horseback or bicycles. After the annexation of Hollywood to Los Angeles in 1910, the Los Angeles Police Department established the Sixth Division with Sergeant E. Carpenter in charge. By 1913, the department was moved to 1625–1629 North Cahuenga Boulevard, addresses housing both the fire and police departments.

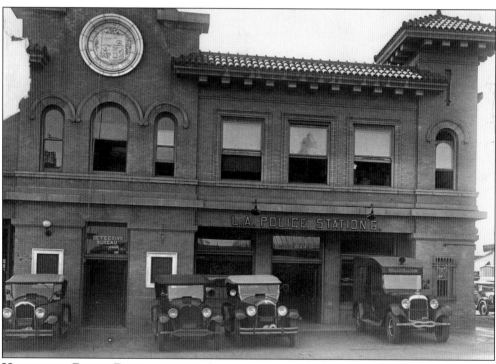

HOLLYWOOD POLICE DIVISION, 1927. A new station was built at 1625–1629 North Cahuenga Boulevard in 1913. The new brick Los Angeles Police Station No. 6 housed at first the police and fire departments in one building. Later the two were separated into adjacent buildings. In 1914, twenty officers worked out of the station, and by the 1920s, traffic and detective divisions were formed. With the tremendous growth of Hollywood at this time, a larger and more modern station was built on Wilcox Avenue.

Three

MOVIES COME TO TOWN
THE STUDIOS AND THEATERS

In 1906, the Selig Polyscope Company of Chicago sent an expedition to California to film scenes for films produced primarily in Chicago. When ocean scenes were needed for *Monte Cristo* in 1907, the company returned and decided to use Southern California for future films. In 1908, director Francis Boggs filmed scenes on a Main Street rooftop in Los Angeles and later moved his productions to the yard of Sing Lee Laundry on Olive Street. At this site, the Selig Company filmed some scenes for *The Heart of a Race Tout* (1909), the first dramatic motion picture filmed on the West Coast. Col. William Selig decided to build California's first motion picture studio at Edendale, north of Los Angeles.

In 1909, the New York Motion Picture Company sent their Bison Western film company to Edendale. The following year, the Biograph Company, headed by director D. W. Griffith, settled in Los Angeles. Griffith shot scenes in the Hollywood Hills and in the Cahuenga Pass for *In Old California*, making it the first dramatic film shot in Hollywood proper. On October 7, 1911, Nestor Film Company arrived from New Jersey and set up the first motion picture studio in the Hollywood area in the former Blondeau Tavern on the northwest corner of Sunset Boulevard and Gower Street. Company president David Horsley leased the roadhouse, using corrals for the horses, storing props in the barn, and using bungalows for dressing rooms and offices. Nestor built a large, open-platform stage and filmed the first studio scenes in Hollywood as well as location shots in the Hollywood Hills for *The Law of the Range*, the first film made by a Hollywood studio. The Nestor Studio also made *Her Indian Hero* and two serials, *Mutt and Jeff* and *Desperate Desmond*, all supervised by director Al Christie.

In May 1912, the newly formed Universal Film Manufacturing Company of New York opened its first studio across the street from Nestor. In the same year, the Universal Film Company leased former rancho lands in North Hollywood, and in 1915 moved all production from Hollywood to the newly created Universal City Studios. In December 1913, the Jesse L. Lasky Feature Play Company, headed by Lasky, Samuel Goldfish, and Cecil B. DeMille, leased the Burns and Revier studio on the southeast corner of Selma Avenue and Vine Street. The Lasky Company came to Hollywood to produce their first film, *The Squaw Man*, released in 1914. *The Squaw Man* is recognized as the first feature film shot in the Hollywood area. The Lasky studio consisted of a barn, laboratory, and open stage. In 1916, the Lasky Company merged with Paramount Pictures and Adolph Zukor's Famous Players Company, making the Lasky Studio the first major motion picture studio originating in Hollywood.

31

UNIVERSAL FILM MANUFACTURING COMPANY, 1915. The newly opened administration buildings were located on Lankershim Boulevard in the township of Lankershim, later known as North Hollywood, at the northern mouth of the Cahuenga Pass. The company originally was headquartered on the northwest and southwest corners of Gower Street and Sunset Boulevard in Hollywood and leased the San Fernando Valley property as a location ranch in 1912. By 1915, Universal Pictures formally opened as a combined ranch and studio facility.

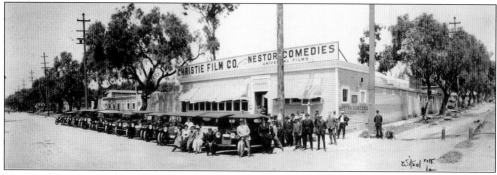

NESTOR/UNIVERSAL/CHRISTIE STUDIO, 1913. In 1911, brothers David and William Horsley of the Centaur-Nestor Company of Bayonne, New Jersey, leased the then-closed Blondeau Tavern at Sunset Boulevard and Gower Street. Al Christie, director-general of the company, remodeled the property into Hollywood's first motion picture studio. Christie is seen, front center, leaning on the car, with his staff at the newly rebuilt studio after a fire destroyed the old tavern building.

THE SQUAW MAN, 1913.
The Jesse L. Lasky Feature Play Company poses at the beginning of filming their first location assignment in the northeast San Fernando Valley. The first day of shooting Hollywood's first feature-multi-reeled motion picture, *The Squaw Man*, was December 29, 1913. Director-general Cecil B. DeMille, seated left on the running board, codirected the film with Oscar Apfel. Also seen here are stars Dustin Farnum (center, white shirt) and Red Wing (light shirt, long hair).

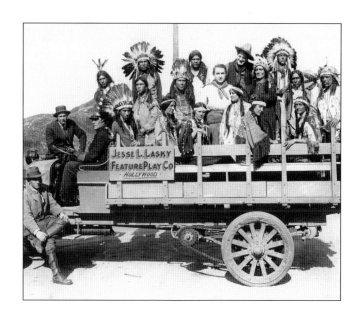

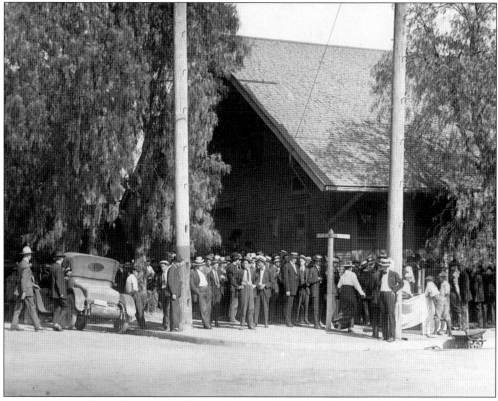

LASKY-DEMILLE BARN STUDIO, 1915. Once known as Hollywood pioneer Jacob Stern's horse barn, this studio was located on the southeast corner of Selma Avenue and Vine Street in Hollywood. The Lasky Studio was established there in 1913 with a stage and laboratory. Here the company produced Hollywood's first feature film, *The Squaw Man*. The Lasky Company eventually evolved into Paramount Pictures, and today the barn is the Hollywood Heritage Museum.

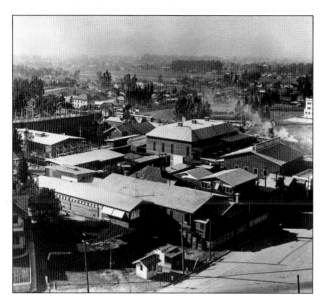

TRIANGLE-FINE ARTS STUDIO, 1916. In 1912, two motion picture entrepreneurs, Harry Revier and J. J. Burns, leased the Thoren farm for use as a movie studio. Located the Sunset/Hollywood Boulevards intersection, the farm/studio featured a stage and laboratory. By 1913, after Revier and Burns vacated, the Kinemacolor Company, an early color production outfit and laboratory, took control. The property changed hands several times until it became the Triangle-Fine Arts Studio of D. W. Griffith, where *The Birth of a Nation* (1915) and *Intolerance* (1916) were produced.

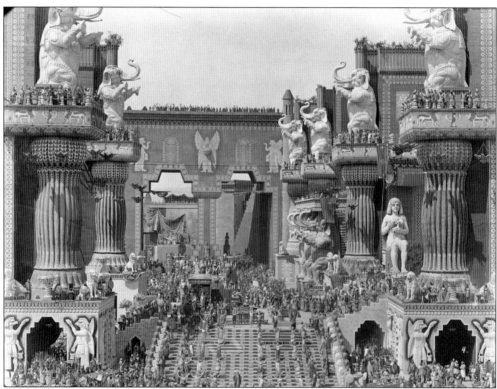

INTOLERANCE BABYLON SET, 1916. The setting for the Babylon sequences in D. W. Griffith's *Intolerance* became Hollywood's first internationally known tourist attraction until they were removed in 1921. The set stood around 125 feet high and could be seen for miles around. The most expensive film of that time, it cost over $500,000, when a typical production ran $25,000 to $30,000. The Fine Arts Studio back lot was on the northeast corner of Sunset Boulevard and Hillhurst Avenue and is now the site of the Vista Theater, which has been in continuous operation since 1923.

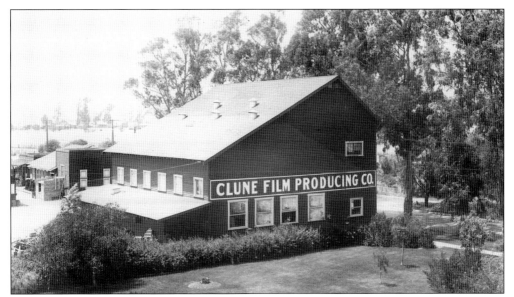

CLUNE STUDIO, 1916. The Fiction Film Company and later Famous Players Film Company occupied a farm on the southeast corner of Melrose and Bronson Avenues in 1914. After Famous Players star Mary Pickford completed only one film there, William Clune purchased the property and expanded the facility into the Clune Producing Corporation. His first production was *Ramona* in 1915. By 1919, Douglas Fairbanks took over the lot and filmed several action films there, notably *The Mark of Zorro* (1920) and *The Three Musketeers* (1921).

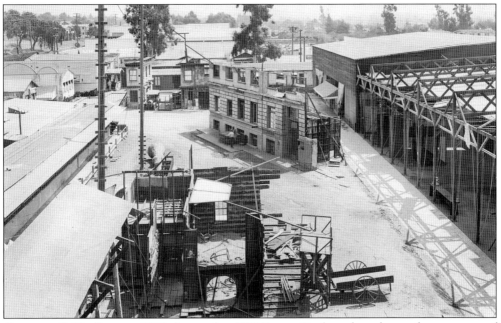

CENTURY–L-KO STUDIO, 1921. Located at 6100 Sunset Boulevard on the southwest corner of Gower Street, this site originally held Universal Studio in 1912. The L-KO Comedy Company, a Universal subsidiary, took over the lot in 1914. The Century Film Corporation, also a Universal company, joined as cotenants in 1917, staying until the studio burned in 1926. It became a baseball stadium and, in the 1970s, a shopping center named Gower Gulch.

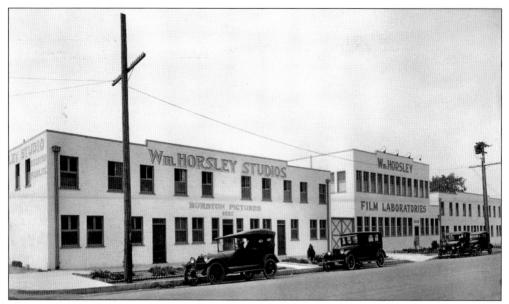

WILLIAM HORSLEY STUDIO, 1920. Located at 6050 Sunset Boulevard, on the southwest corner with Beachwood Drive, the Horsley studio was built in 1919 as a rental studio for independent producers. At 6060 Sunset was the Horsley Laboratories. On the corner of Sunset Boulevard and Gower Street was the Paulis Studio. These independents in and around Beachwood Drive would later be called "Poverty Row" studios, known for low budget filming.

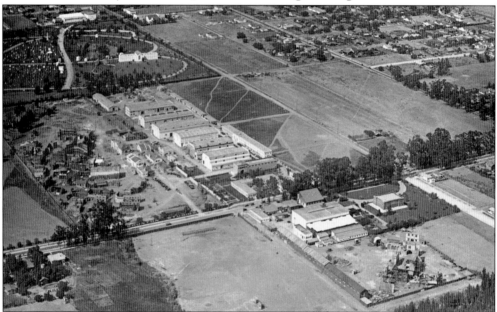

ROBERT BRUNTON AND CLUNE STUDIOS, 1920. Brunton Studio, center, was originally established as the Paralta Studio in 1918 for independent productions. By 1924, the studio became known as the United Studios, where Rudolph Valentino and the early United Artists were headquartered. Paramount moved to the site in 1926 where it is still located today. At the bottom right is the William H. Clune/Douglas Fairbanks Studios established on the site since 1914. Today Raleigh Studios is located at Bronson and Melrose Avenues.

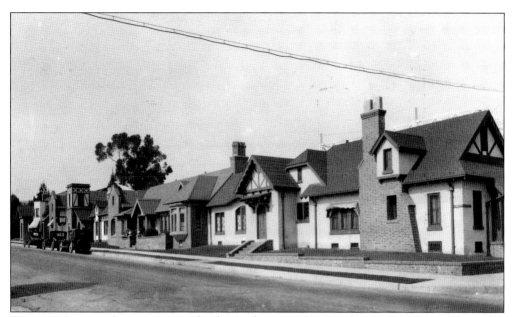

CHARLES CHAPLIN STUDIO, 1924. Chaplin Studio, created in 1919, became a Hollywood landmark because of its English cottage–style design, created to hide the studio behind it. Located at 1416 North La Brea Avenue, the studio was the headquarters for all of Chaplin's films until he moved to Switzerland in 1952.

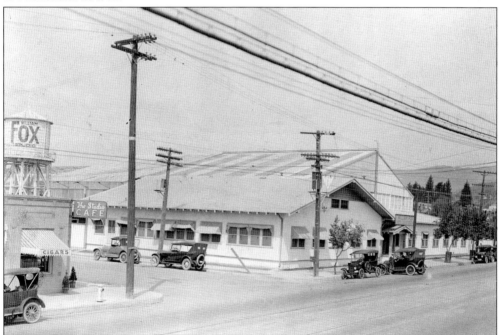

WILLIAM FOX STUDIO, 1921. Fox Studios, at 1417 Western Avenue, was a former farm. Thomas Dixon inaugurated the studio in 1915. Dixon was the author of the controversial 1905 novel and film, *The Clansmen*; D. W. Griffith later used the story for his epic film *The Birth of a Nation*. The Fox Studios expanded to both sides of Western Avenue and remained at Sunset Boulevard and Western Avenue until 1971, when it was demolished to build shopping centers.

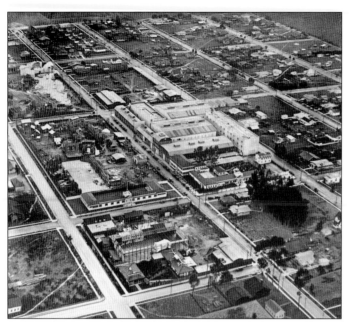

METRO PICTURES STUDIO, 1921. Originally established at the northwest corner of Eleanor Avenue and Lillian Way, Metro was established in a Hollywood bungalow in 1915 that was previously the Charles Chaplin Lonestar Studio. By 1920, the studio had expanded into five lots, making it one of Hollywood's most notable landmarks. Rudolph Valentino and Jackie Coogan became superstars here. In 1924, some of the buildings were moved to the newly merged Metro-Goldwyn-Mayer in Culver City.

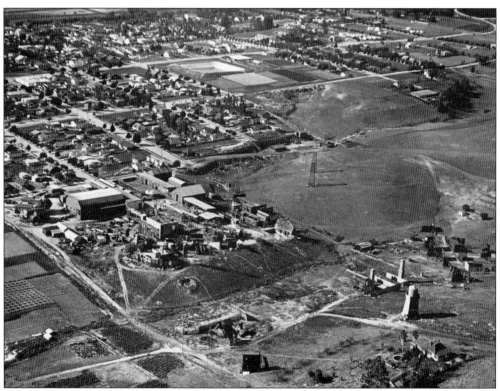

VITAGRAPH STUDIO, 1921. This aerial photograph shows the Vitagraph Studio in East Hollywood, with the corner of Prospect and Talmadge Avenues in the far left center, which is where the studio administration buildings and main enclosed stage were located. Vitagraph moved to this site from Santa Monica in 1915 and expanded into the eastern foothills.

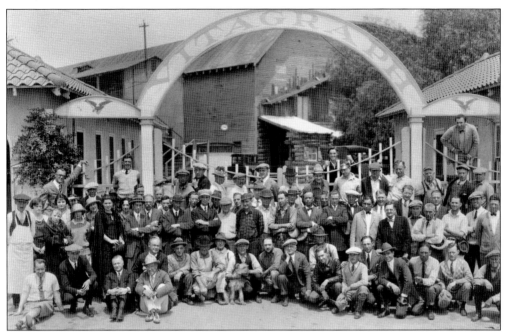

VITAGRAPH STUDIO, 1925. In 1925, the studio merged with Warner Brothers and became Warner East Hollywood Annex. Here Vitagraph founders Al Smith and J. Stuart Blackton sit on the ground, third and fourth from left, prior to the merger. Outdoor scenes were shot on the back lot for *The Jazz Singer* (1927) and *Captain Blood* (1935). By 1949, ABC had bought and renamed it ABC Television Center. In 1996, ABC became a division of Walt Disney, and in 2002, the lot was renamed Prospect Studio.

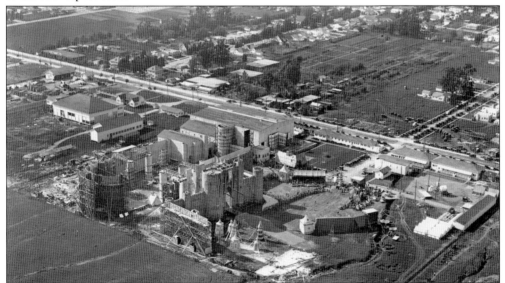

PICKFORD-FAIRBANKS STUDIO, 1922. This aerial photograph was taken during the filming of Douglas Fairbanks's epic *Robin Hood*. Looking northwest to Santa Monica Boulevard are the castle sets that stood approximately 140 feet high. The studio at 7200 Santa Monica Boulevard later became United Artists, Samuel Goldwyn, and Warner Hollywood studios. In the 1990s, it became the Lot, a rental studio. Visible on the western side of the studio is King Vidor Studio, established in 1920.

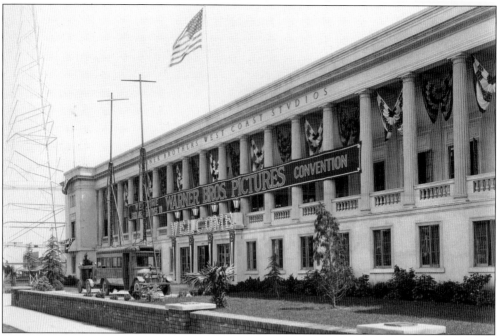

WARNER BROTHERS STUDIO, 1925. A KFWB remote unit is parked in front of the Warner Brothers Studio at 5842 Sunset Boulevard during an exhibitors' convention. The Warner studio was established on Beesemyer Farm in 1920, between Van Ness and Bronson Avenues, and by 1923 had built most of the studio that still exists today. Warners were the first to invest in sound motion pictures, making such groundbreaking films here as *Don Juan* (1926) and *The Jazz Singer* (1927).

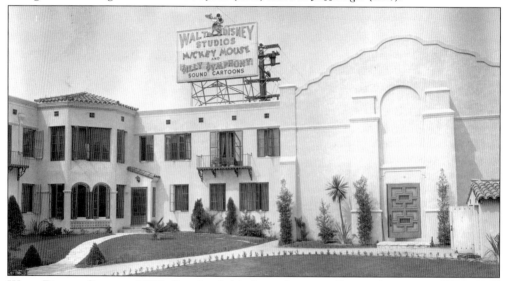

WALT DISNEY STUDIO, 1930. Starting behind a real estate office at the corner of Kingswell and Hillhurst Avenues a few blocks from the Vitagraph Studio in East Hollywood, Disney had purchased land in the Silver Lake district near East Hollywood by 1925. The studio at 2719 Hyperion Boulevard was built quickly. The first successful sound cartoon series was *Mickey Mouse in Silly Symphonies*, made at Silver Lake. The Disney Studio remained on Hyperion until 1939, when it moved to Burbank.

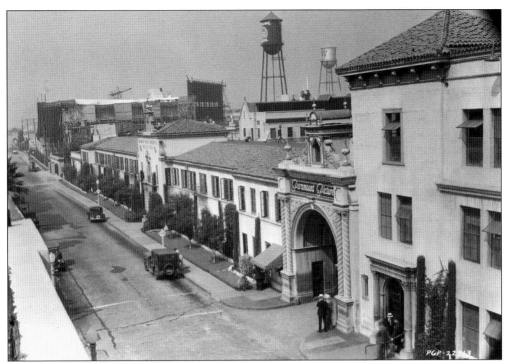

PARAMOUNT STUDIO, 1936. Paramount purchased this studio lot from United Studios in 1926 and moved from quarters at Sunset Boulevard and Vine Street. The property was remodeled and expanded. It was on this lot that Cecil B. DeMille shot from 1932 on, including *Cleopatra* (1934), *The Crusades* (1935), *The Greatest Show On Earth* (1952), and *The Ten Commandments* (1956). Paramount classics shot on the lot included *Wings* (1927), *Morocco* (1930), *Double Indemnity* (1944), *Sunset Boulevard* (1950), *The Godfather* (1972), and the *Star Trek* movies.

RKO STUDIO, 1940. The northeast corner of Gower Street and Sunset Boulevard became a Hollywood landmark with the signature Art Deco soundstage, the film advertisement billboards, and the RKO Radio tower. The RKO Studio entrance was at 780 North Gower Street, one block north of Melrose Avenue. Between 1921 and 1927, the Robertson-Cole and later Film Booking Offices built basic facilities on Gower before the RKO company took them over in 1928 and expanded the studio. Scenes from *King Kong* (1933), *Citizen Kane* (1941), and the Astaire-Rogers musicals, among many other classics, were shot at RKO.

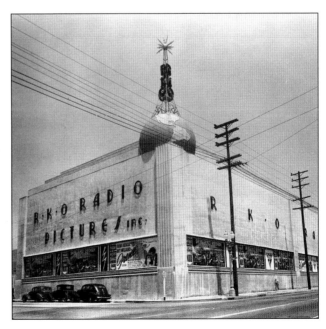

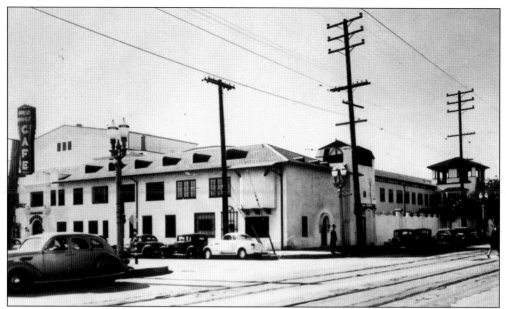

UNITED ARTISTS STUDIO, 1937. Originally the site of the Jesse D. Hampton Studio from 1919, the studio lot expanded with its purchase by Douglas Fairbanks and Mary Pickford in 1922. Named the Pickford-Fairbanks Studio, it was to be the home of United Artists, which the pair helped to create in 1919. In 1927, the studio was renamed United Artists Studio, with address of 1041 North Formosa Avenue. Samuel Goldwyn joined the company in 1925 and by 1939 took control of United Artists and renamed the studio the Samuel Goldwyn Studio.

COLUMBIA STUDIO, 1935. Cohn-Brandt-Cohn Studios (CBC), the predecessor to Columbia Pictures, was located at the southeast corner of Gower Street and Sunset Boulevard starting in 1920. Columbia came into existence in 1924 at 1438 North Gower Street, just south of Sunset Boulevard. The Columbia lot was acquired over a period of years, adding more facilities and stages in a compact arrangement. In 1968, Columbia TV-Screen Gems was formed and located on Beachwood Drive around the corner from the main lot. In 1971, Columbia moved to Warner Brothers Studio in Burbank, creating a joint venture: Burbank Studios.

COLUMBIA STUDIO, 1939. The inner main lot of Columbia was one of the most compact studio facilities in existence at that time. All departments were contained in one small area of the lot and were close to every stage, dressing room, and technical area. Many classics were made on this lot, including *It Happened One Night* (1934), *Mr. Smith Goes To Washington* (1939), *Lost Horizon* (1937), *Gilda* (1946), and 190 Three Stooges comedies.

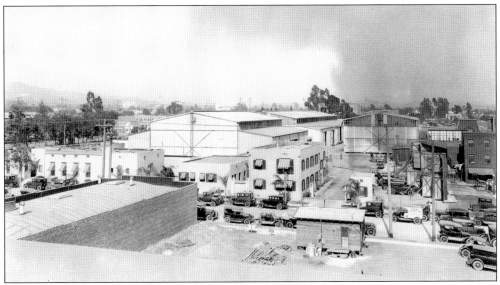

METROPOLITAN STUDIO, 1925. Originally built as the Jasper Hollywood Studio in 1919, this old, silent-era studio was host to Harold Lloyd and Howard Hughes. In 1925, Al and Charles Christie took over the studio at 1040 North Las Palmas Drive and by 1928 remodeled it into an independent sound facility. By 1933, the studio was known as the General Service Studios where United Artists, Universal, Paramount (Mae West unit), and other companies utilized the lot's services. In 1980, the studio lot became Francis Ford Coppola's Zoetrope Studio until 1984, when it was sold and renamed the Hollywood Center Studios.

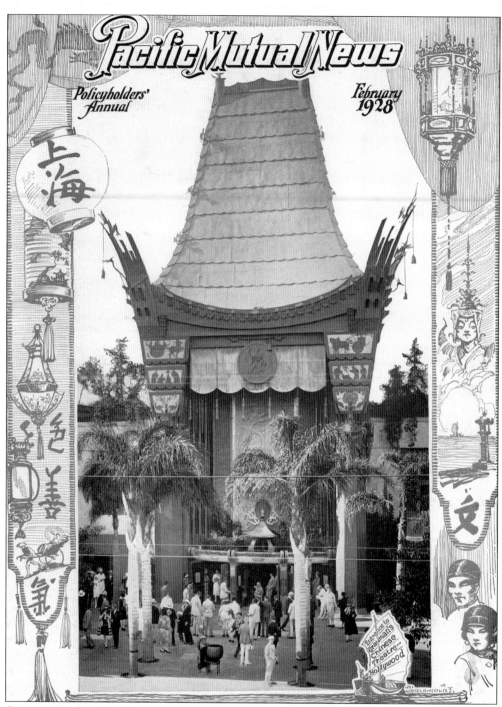

GRAUMAN'S CHINESE THEATRE, 1928. This famous theater was featured on the cover of the *Pacific Mutual News* in February 1928, illustrating its importance and popularity one year after it opened. Grauman's Chinese Theatre has symbolized Hollywood to people around the world for decades and continues to do so to this day.

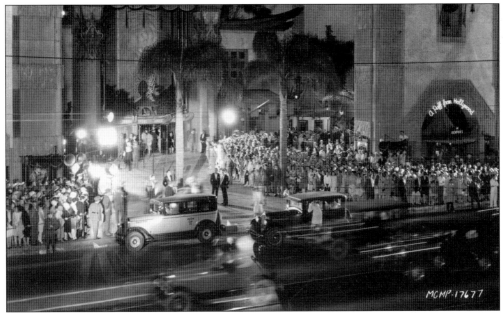

GRAUMAN'S PREMIERE, 1929. Premiered *The Idle Rich* here starring Conrad Nagel and Leila Hyams. Sid Grauman had originated the "studio premiere" four blocks to the east at his Egyptian Theater in 1922. The success of premiere events for the studios, stars, public, and of course the theater led to the development of the Chinese Theater's larger forecourt. The theater expanded capabilities for more prominent public presentations and media interviews with arriving celebrities.

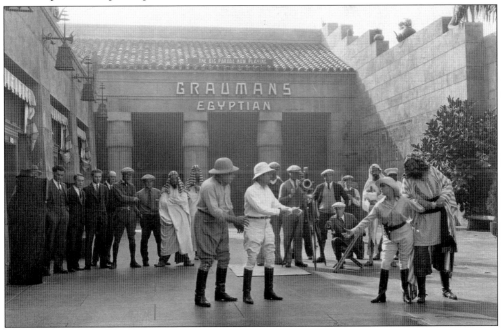

GRAUMAN'S EGYPTIAN THEATRE, 1927. The Joe Rock Comedies go "on location" at the Egyptian Theatre in Hollywood. Both the Egyptian and Chinese theaters were used by the studios for their exotic backgrounds and as backgrounds for Hollywood-themed film stories that used the real-life theaters as stars themselves.

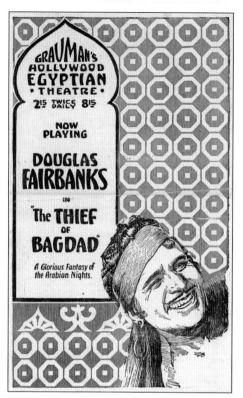

EGYPTIAN THEATRE HERALD, 1924. This is a souvenir herald from *The Thief of Bagdad.* Fairbanks's fantasy of the Arabian Knights was inspired by epic fantasies coming from Europe, such as Fritz Lang's *Die Nibelungen* and Paul Leni's *The Waxworks.* The film was another triumph for Fairbanks and the Egyptian Theater. Two years earlier Fairbanks's co-star, Julanne Johnston, received early notice for her role as *The Dancer,* which she had actually peformed in 1922 in Sid Grauman's stage prologue at the Egyptian Theater during the run of Douglas Fairbanks's *Robin Hood.*

GRAUMAN'S EGYPTIAN THEATRE, 1922. This interior shot shows the large columns that gave support on each side of the proscenium. The right column and proscenium were removed in 1955 to expand the screen for 70-mm films with the opening of *Oklahoma!* The larger, left column and arch were removed for the installation of the curved Dimension-150 movie screen in the late 1960s. The plaster pharaoh's head shown in between the columns was sold and resides somewhere in Southern California.

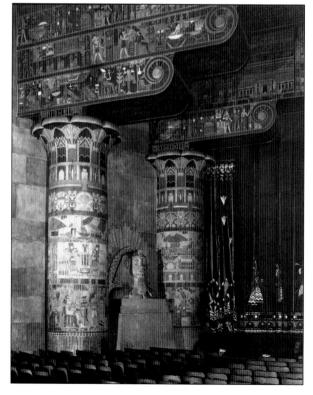

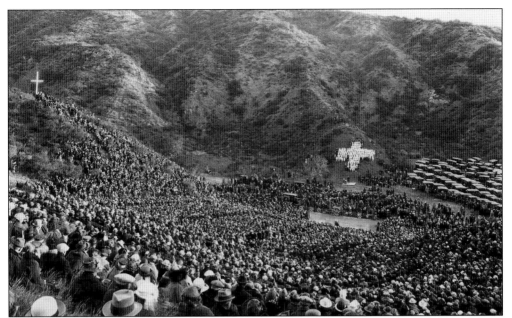

HOLLYWOOD BOWL, 1923. Easter sunrise services started here in 1922, and by 1923, benches for 25,000 patrons had been added to the hillside. The Hollywood Bowl Park at that time was 65 acres with 5 acres used for hillside seating, which peaked at almost 500 feet above the stage. At this time, a similar service was held at Christmas but was soon abandoned.

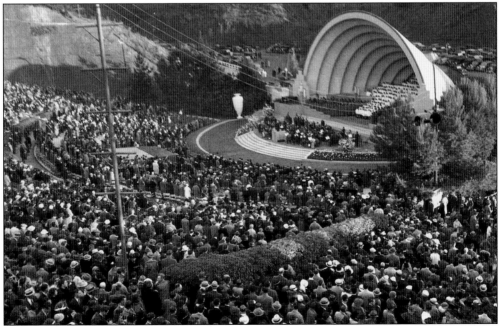

HOLLYWOOD BOWL, 1936. The famed 1929 orchestra shell is shown containing a cross created by members of the choir, as in the previous services. By this time, new seating had been added, reducing the capacity to 20,000 people, with cars still parking behind the shell. The shell was on rollers and could be moved back toward the hill for large-scale opera and ballet productions. The shell would be demolished in 2003 for a larger one, ostensibly to better accommodate rock concerts.

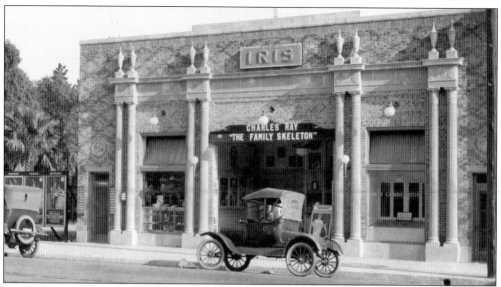

IRIS THEATER, 1916. Originally called the Idyl Hour Theatre, this was the first theater in Hollywood, opening in 1913. The second version of this theater opened across the street in 1916 and would be remodeled into an Art Deco design inside and out about 1930. Originally seating over 800 people, its capacity had been reduced to 647 by the time it closed in 1989. Carol Burnett worked here as an usher after leaving the Hollywood Warner Theater across Hollywood Boulevard to the east.

BARD'S THEATER, 1923. Opened in 1923 on the back lot of the Griffith-Triangle Studio, the Bard was a part of a small chain of Los Angeles area theaters. The site had previously been used for D. W. Griffith's massive Babylon sets for the film *Intolerance* in 1916. The sets remained until 1921 when the fire department ordered their removal. An attempt to keep the deteriorating set for a future Hollywood museum lacked funding. Instead, the set was razed for an 800-seat theater with an Egyptian-style interior, later renamed the Vista Theater. Today the Vista remains as a restored, first-run theater in East Hollywood.

HOLLYWOOD PANTAGES THEATER, 1934. Opened on June 4, 1930, the Pantages was Hollywood's last and largest movie palace, seating 2,812. It had the second largest stage west of Chicago (the Shrine Auditorium near downtown Los Angeles was the largest). One of the first—if not the first—Art Deco–style movie palaces built in the world, the building was to have been 12-stories tall. But the Depression kept it at only at two stories. The theater was sold to Howard Hughes's RKO Pictures in 1949, and Hughes kept an office on the second floor.

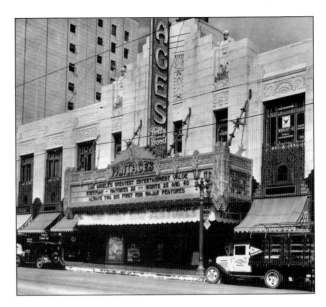

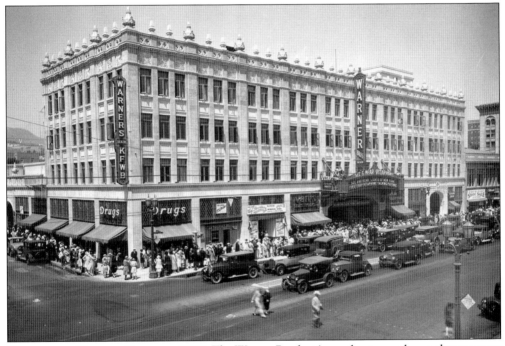

HOLLYWOOD WARNER THEATER, 1928. The Warner Brothers' new theater on the northeast corner of Wilcox Avenue and Hollywood Boulevard is seen during the premiere of *Lights of New York*. Built in 1927 to open with *The Jazz Singer* starring Al Jolson, the theater was delayed because of construction overruns and the death of Sam Warner. Finally, on April 26, 1928, it opened. Jolson was there as the emcee, but it was for the theater's belated opening night of *The Glorious Betsy*. Seating 2,753 and costing over $2 million, the theater was the largest in Hollywood at the time and one of the most expensive buildings. The opening-night program said that it was designed as an "atmospheric" theater (the only one in Los Angeles) and described it as "The Castle in Spain," with clouds, stars, and the moon projected overhead in the elaborate interior.

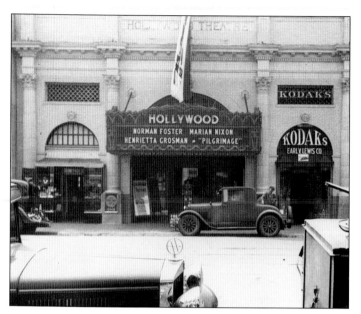

THE HOLLYWOOD THEATER, 1933. With a seating capacity of 917, the Hollywood Theater was the second to open in Hollywood (after the Iris). The Beaux-Arts facade was removed in 1938 for a new Streamline Moderne design by Claude Beelman. The brick and terra-cotta facade was recycled as landfill underneath the new theater floor, which had been raised during the 1938 remodeling. It was converted into a Guinness World of Records Museum in 1991.

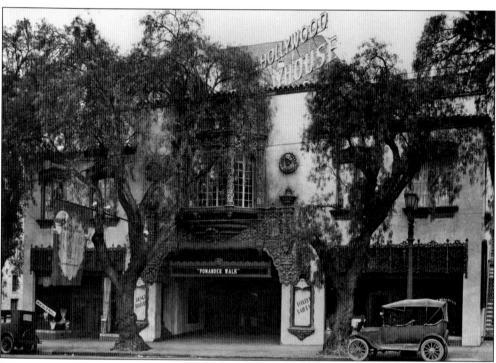

HOLLYWOOD PLAYHOUSE THEATER, 1928. This was one of four legitimate theaters built on Hollywood Boulevard between 1925 and 1927, each seating over 1,000 people. The playhouse opened on January 24, 1927, and solidified Hollywood as a legitimate theater district, second only to downtown Los Angeles. Broadway and Hollywood star E. E. Clive produced shows here in the 1930s, including *Woman on Trial* in the fall of 1933. It was written by the then-unknown author Ayn Rand and was her first play. It would go on to Broadway and become known by its more famous title, *The Night of January 16th.*

EL CAPITAN PROGRAM, 1928. This April 8 program was for the show *New Brooms* featuring Jason Robards Sr. The program was full of fashion, travel, furnishings, restaurant, and housing advertisements for area businesses. Information on the theater, the plays, and the actors was interspersed with the advertisements.

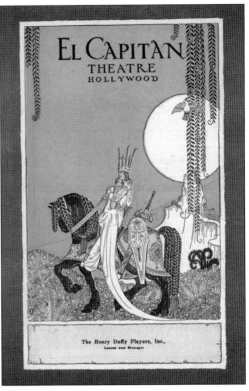

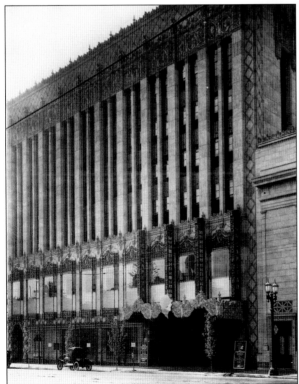

EL CAPITAN THEATER, 1926. Originally opened in 1926 as Hollywood's largest legitimate theater, with seating for 1,550, it was called "Hollywood's Home of the Spoken Drama." Built by Hollywood pioneer C. E. Toberman, it was his second of three theaters in Hollywood (the other two were the Grauman's Egyptian and Chinese theaters) and was operated by theatrical producer Henry Duffy. Over 120 plays were staged there until 1941, when it became a movie theater. Stars such as Clark Gable, Buster Keaton, Mary Pickford, Gertrude Lawrence, Bob Hope, Joan Fontaine, Henry Fonda, Will Rogers, and many more performed here.

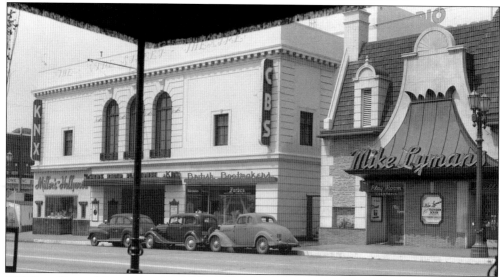

CBS Lux Radio Theater, 1940. The Wilkes Vine Street Theater was later known as the CBS Lux Radio Theater. Opening on March 14, 1927, it was an initial success. But the Depression would force its conversion to a movie house by the early 1930s. CBS Radio, which only had small studio space on Sunset Boulevard, used it as a principle location for radio shows, which required large audiences, until 1954, when television became the dominant entertainment form. The most famous show to broadcast from here, from 1939 until 1954, was the *Lux Radio Theatre*, a weekly one-hour dramatization of popular movies with many of the original stars.

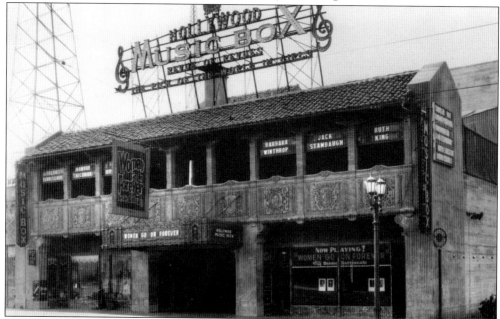

Music Box Theatre, 1931. Opened in 1926 by actor-producer Carter DeHaven (father of actress Gloria DeHaven), this legitimate theater on Hollywood Boulevard near Gower Street hosted original and touring plays. One was a late-1920s tour of *Dracula* starring Bela Lugosi. By 1936, radio programs were broadcast from here, including *Lux Radio Theater*, which aired until 1939, followed by NBC programs, including the *Dinah Shore Show*.

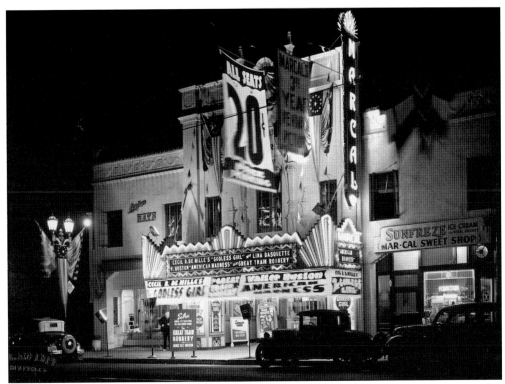

MARCAL THEATER, 1937. Built in 1928 on Hollywood Boulevard near Bronson Avenue, this theater was funded by film stars Lon Chaney and Alice Calhoun, who combined the names of her business manager and herself, forming the name "Mar-Cal." The name was solidified into the Marcal Theater, which was converted into a neighborhood movie house. By 1935, the Marcal was taken over by Al Galston, who converted it into a revival house in 1937, showing silent movies.

IRIS THEATER, 1936. Totally remodeled into a Streamline Moderne–style theater, the Iris would be remodeled again and renamed the Fox Theater in 1968. When the Hollywood Walk of Fame was being placed in front of the theater in 1960, Alfred Hitchcock's *Psycho* was playing there. As a tribute, Hitchcock's star was placed in front of the theater.

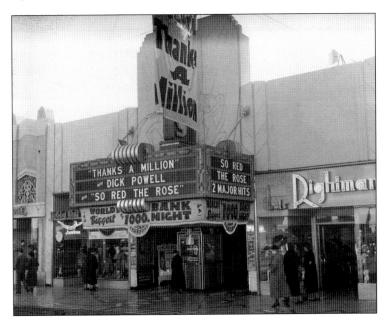

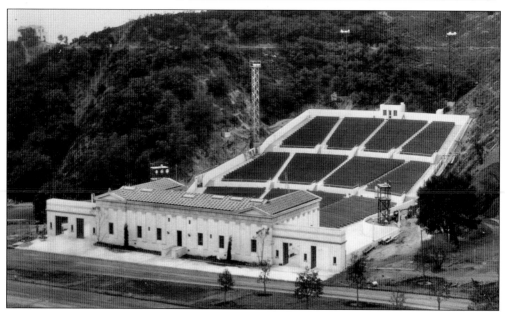

GREEK THEATER, 1931. In 1896, Col. Griffith J. Griffith donated 3,000 of the 4,000 acres of his Los Feliz Rancho to the City of Los Angeles, lands that became Griffith Park. His will in 1919 stipulated that $1 million be used to build a Greek theater and planetarium in the park. The theater was not to cost more than $100,000. Opened in 1930, the theater burnt down after a year. A more substantial one was built for the 1931 reopening. Numerous operas and ballets played there in the 1930s as did the Works Progress Administration's Federal Theater (WPA).

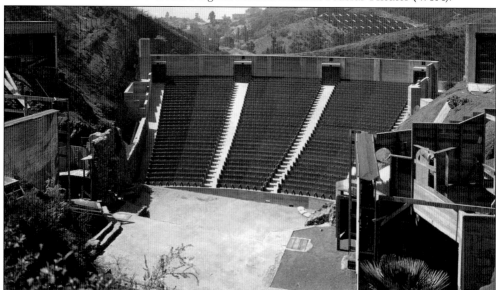

PILGRIMAGE PLAYHOUSE, 1931. In 1920, Christine Witherill Stevenson left the Hollywood Bowl project to pursue her original idea of opening a Pilgrimage Play Theater for plays based on the Bible. She built a wooden amphitheater across the Cahuenga Pass from the bowl site, operating it until her death in 1923. The theater burned down in 1929 and was rebuilt in 1931 with reinforced concrete. Except for closing during World War II, the playhouse continued on until 1964. The county of Los Angeles today owns the facility, known as the John Anson Ford Theater.

Four

THE HOLLYWOOD HOTEL
AND
HOLLYWOOD HOTELS

The Los Angeles Pacific Boulevard and Development Company was incorporated in 1901 to develop land at the mouth of Cahuenga Pass known as the Hollywood Ocean View Tract. *Los Angeles Times* publisher Harrison Gray Otis, H. J. Whitley, and George W. Hoover were investors. A commercial district on Highland Avenue and a gateway hotel on the northwest corner of Highland and Prospect Avenues were parts of the plan. Hoover completed the first 40-room unit of the Hollywood Hotel in February 1903. By 1907, other wings were built, adding 104 rooms to the complex that dominated the Hollywood landscape for decades to come. At this time, the hotel was sold to Mira Hershey of the Hershey's Chocolate Company of Pennsylvania. Margaret J. Anderson, a widow with two children, invested in the hotel's expansion and undertook the management. On May 14, 1911, it was announced that a huge mission-style hotel was to be erected by Anderson in the Beverly Hills area. Anderson left Hollywood and embarked on the project of her life.

Anderson had converted the Hollywood Hotel almost immediately into the social center of the growing community. Weddings, social events, and business meetings were held at the hotel. As film studios came to Hollywood, arrivals stayed at the hotel instead of commuting from Los Angeles. When playwright William de Mille came in 1915, invited by his brother, Cecil B. DeMille, he stayed at the Hollywood Hotel and walked to the Lasky Studio on Vine Street. William said the hotel had a relaxing influence on him. Between 1915 and 1920, most of the motion picture colony stayed at or visited the hotel, including Douglas Fairbanks, Charles Chaplin, Dustin and William Farnum, Anita Stewart, Lon Chaney, Rudolph Valentino, and Pola Negri.

The three-story Sackett Hotel at Hollywood and Cahuenga Boulevards was opened by Horace D. Sackett in 1888. The Cahuenga Valley's first hotel became a haunt of cowboy film stars and stuntmen, while their horses would stay at the Sunset Livery and Boarding Stables.

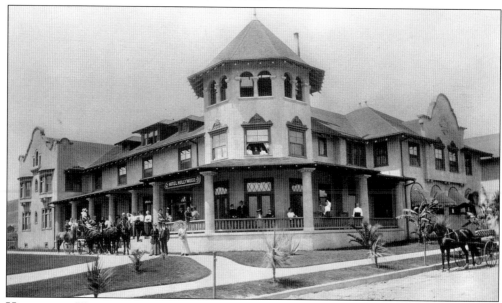

HOLLYWOOD HOTEL, 1903. Opened in 1903 with 40 rooms, this hotel immediately became the community center for Hollywood's 700 residents. At the northwest corner of Prospect Avenue (later Hollywood Boulevard) and Highland Avenue, the hotel was built by Hollywood pioneer George W. Hoover of the Los Angeles Pacific Railroad and Development Company. Here, on November 14, 1903, by a vote of 88 to 77, Hollywood became its own city. The Hollywood Board of Trade spearheaded the movement to upgrade the community's image and improve public services. Reflecting its conservative Midwestern roots, the board declared the city alcohol-free, closing saloons and ceasing alcohol sales by 1904.

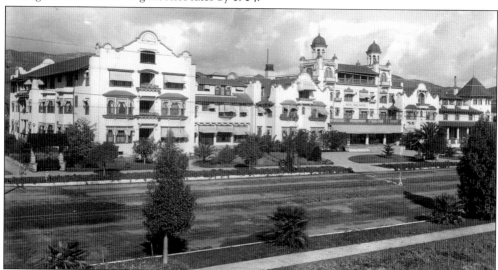

MORE ROOMS, 1910. Famed architects Elmer Gray and Myron Hunt added 104 rooms to the hotel, and they opened on March 15, 1905. George W. Hoover sold the hotel to Myra Hershey of the Pennsylvania chocolate fortune in 1907. The mission/Moorish style of architecture, along with that of Paul de Longpre's home five blocks east of the hotel, helped give exotic flavor to Hollywood and lure tourists. Both were landmarks on the famed Balloon Route Tours as the tourist industry emerged. The Hollywood Hotel was demolished in 1956.

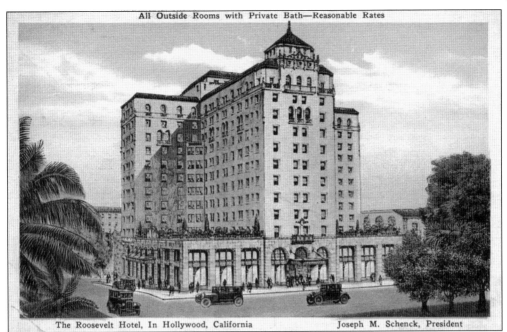

The Roosevelt Hotel, In Hollywood, California Joseph M. Schenck, President

HOLLYWOOD ROOSEVELT HOTEL, 1927. A postcard shows the Hollywood Roosevelt in an architectural rendering. Named after Theodore Roosevelt, it opened in August 1927 as part of a plan by C. E. Toberman to develop the Highland Avenue side of Hollywood. His real estate holdings focused on this area, as opposed to the Vine Street side of Hollywood, where the Hollywood Knickerbocker and Plaza Hotels had recently opened along with three theaters. Toberman countered by developing the El Capitan and Chinese theaters and the Roosevelt Hotel from 1925 to 1927.

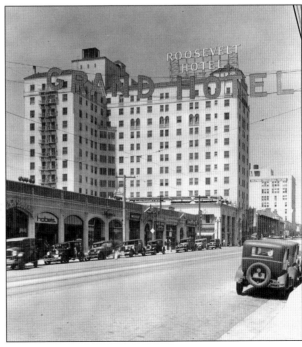

ROOSEVELT HOTEL, 1932. The Roosevelt was located almost directly across Hollywood Boulevard from the Grauman's Chinese Theater. The electric-light street banner for the film *Grand Hotel* hangs from the east side of the theater. These banners were used to promote films at the Chinese, since it had no actual marquee until 1958. Sid Grauman was an original investor in the hotel, along with friends Douglas Fairbanks, Mary Pickford, Louis B. Mayer, Joseph Schenck, and Marcus Loew.

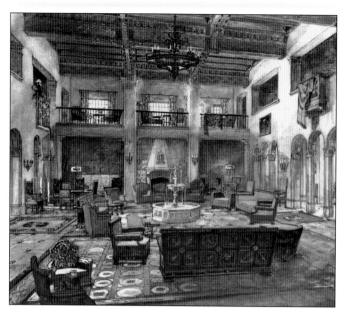

ROOSEVELT HOTEL, 1927. This 12-story hotel had a lavish lobby to accommodate both customers and the visiting public. Elaborate concrete work with stenciling created a beautiful Spanish-style interior. This was covered up decades later with dropped ceilings and false walls in an attempt to modernize the hotel. Removed in 1985 as part of a $12 million renovation, the original room, columns, and mezzanine were restored. In 2005, the management modernized it again by reducing the lighting and removing the check-in desk.

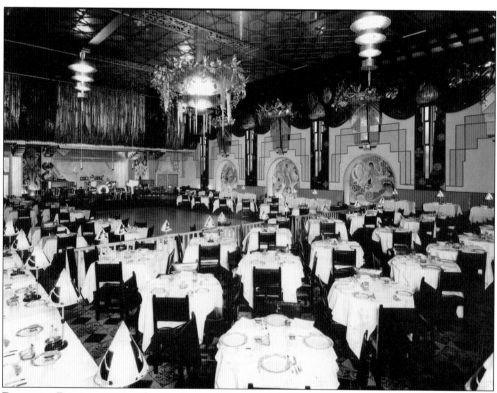

BLOSSOM ROOM, 1934. The Hollywood Roosevelt's Blossom Room from the 1920s to the 1950s served as an entertainment and dance center and was rented for events. Radio broadcasts emanated from here in the 1930s with dance bands playing live over the airwaves. Although not as popular or elaborate as the larger and more famous Cocoanut Grove, the Blossom Room remained a popular nightspot into the 1950s.

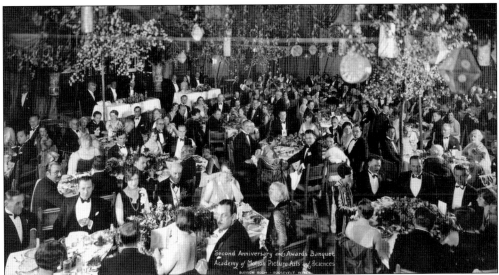

FIRST ACADEMY AWARDS, 1929. The second anniversary and awards banquet for the fledgling Motion Picture Academy of Arts and Sciences was held in the Blossom Room on May 16, 1929. The Academy had moved its office to the Roosevelt Hotel in November 1927, six months after its formation. The office was on the mezzanine, today known as the Academy Room. The academy's most famous involvement with the film industry was instituting an "Award of Merit," now known as an Academy Award, with a statuette named "Oscar." Awards were given then for winners in 12 categories, and Certificates of Honorable Mention went to the 20 "losers," although the winners were announced three months earlier. The evening's host was Douglas Fairbanks, with entertainment featuring Al Jolson, while *Wings* won the first Best Picture award.

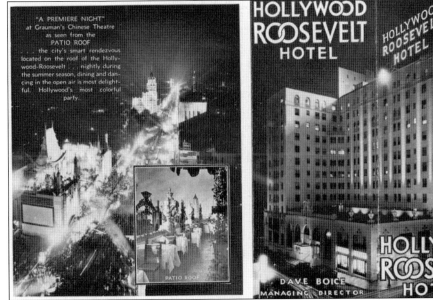

ROOSEVELT BROCHURE, 1930. This hotel brochure shows inside photographs of hotel amenities, room interiors, and banquet facilities. The brochure highlights the Patio Roof and Restaurant in an inset photograph of the premiere of Howard Hughes's epic film, *Hell's Angels*, which took place below the roof terrace that was a popular nightclub in the 1930s.

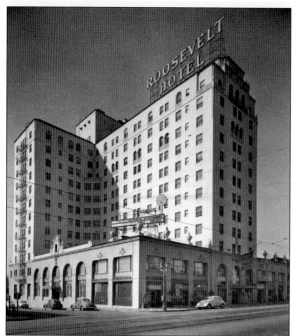

ROOSEVELT HOTEL, 1937. The hotel was host to many film industry events and associations. Marilyn Monroe briefly stayed in room 246 and had her first commercial photographs taken around the pool. The pool was also used for the *I Love Lucy* television show when the Ricardos and the Mertzes came to Hollywood. Montgomery Clift stayed in room 928 while filming *From Here to Eternity* in 1953. In the 1950s and 1960s, the television show *This Is Your Life* held its post-show receptions at the hotel. The tile stairway to the mezzanine is where Bill "Bojangles" Robinson taught Shirley Temple how to do his famous stair-step routine.

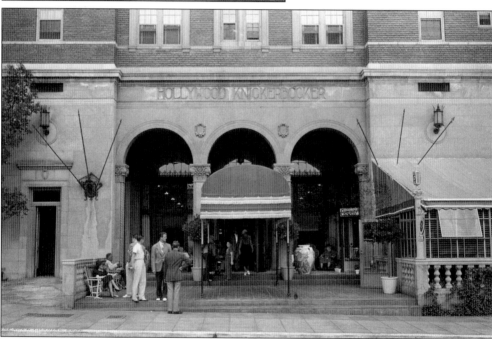

KNICKERBOCKER ENTRANCE, 1937. Advertising itself as "Your home for a day or a year," the Knickerbocker has been a favorite of Hollywood celebrities since it opened in 1925. Built for $1.5 million, it was a luxury hotel that also had long-term rentals. Residents included Judy Garland, Orson Welles, Cary Grant, Bette Davis, and Errol Flynn. Elvis stayed in room 1016 in 1956 while filming his first movie, *Love Me Tender*. Rising film star Frances Farmer was taken from here in 1943 screaming and wearing only a shower curtain after missing a parole hearing. William Frawley, Fred Mertz on *I Love Lucy*, walked out of the hotel bar, collapsed, and died on its front steps on March 6, 1966.

KNICKERBOCKER LOBBY, 1930. This elaborate interior has been unseen for more than 40 years. Various modernizations have covered this interior, starting in the 1950s. The exterior entryway was covered over as well, and the public areas inside were covered in dropped ceilings and false stucco walls to give the place a clean, modern look at the same time the Hollywood Roosevelt Hotel was remodeled. Hopefully this beautiful interior will again be unveiled for all to see.

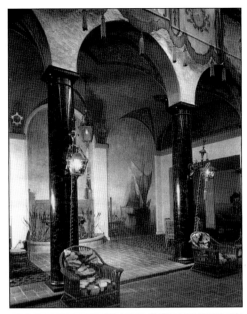

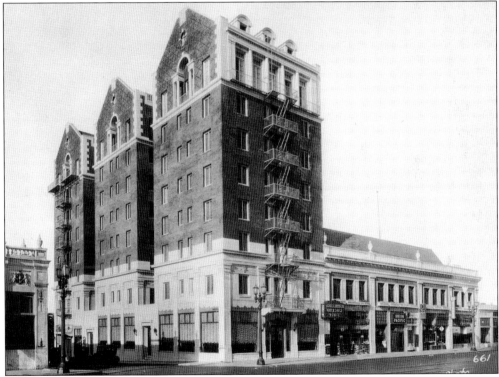

CHRISTIE HOTEL, 1923. Hollywood's first deluxe high-rise hotel was also the first to have a bathroom with each guest room. It opened in 1923, was nine-stories tall, and was developed by H. H. Christie, who was no relation to the Christie brothers of the Christie Studios. The two-story building to the right burned down in the 1950s, except for the former basement site of the New Yorker Club of 1929, which is currently covered by a parking lot. The Drake and Hollywood Inn hotels were on the site before it was taken over by the Church of Scientology.

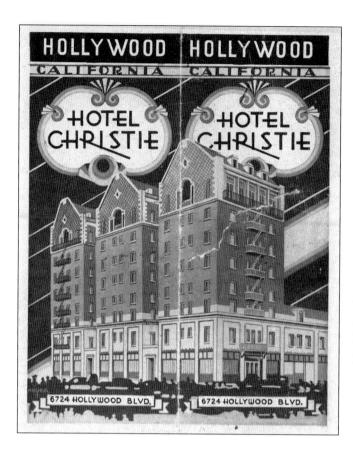

HOTEL CHRISTIE BROCHURE, 1930. With an elaborate brick and terra-cotta facade, this hotel is located at 6724 Hollywood Boulevard and became a well-known landmark near the famous intersection of Hollywood Boulevard and Highland Avenue. "The Christie Grill and Cocktail Lounge is recognized as one of the finest of its kind in the world," reads the brochure. "Ideally situated on the busy corner of Hollywood Boulevard and McCadden Place, Hotel Christie is one of the finest structures in this amazing city of beautiful homes, smart shops, unique theatres and close to all Hollywood Film Studios."

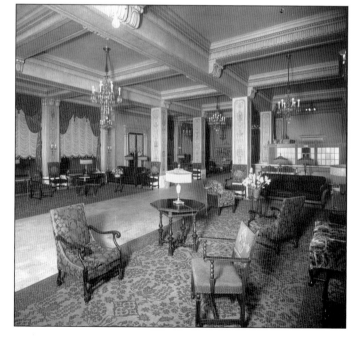

HOTEL CHRISTIE LOBBY, 1923. The interior lobby of the Hotel Christie was of Old World, European design. Los Angeles architect Arthur Kelly designed the Christie to serve the executive film crowd who wanted better accommodations than were provided by the then aging Hollywood Hotel just a block away. The spacious lobby was remodeled several times over the years with everything visible in this photograph being removed.

HOLLYWOOD PLAZA HOTEL, 1926.
Hollywood pioneer Jacob Stern built this 10-story, 200-room hotel, managed by his son Eugene, on his property in 1924–1925. The hotel was designed by Walker and Eisen, who had designed the Taft Building across Vine Street the previous year in a similar Renaissance Revival style. The Plaza was meant to be a New York–style hotel and became popular with live-theatre and radio performers working in town, including Jackie Gleason, Doris Day, Marilyn Monroe, and Everett Edward Horton who, besides starring in movies and plays, produced shows at the neighboring Vine Street Theater.

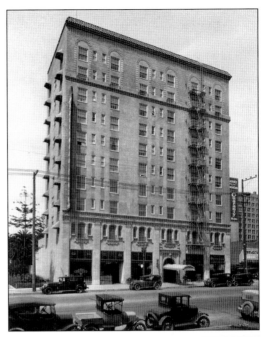

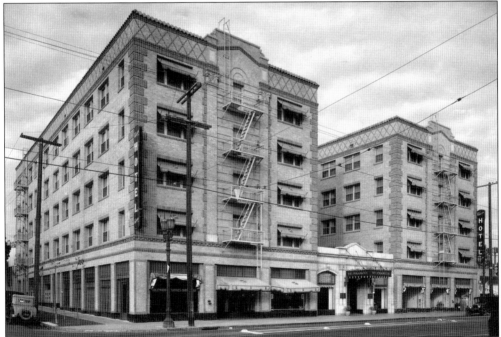

ST. FRANCIS HOTEL, 1925. Located at 5533 Hollywood Boulevard just west of Western Avenue, the St. Francis was an excellent apartment hotel servicing East Hollywood. The five-story building had street-level storefronts, including the Hollywood Securities Corporation, on the northeast corner of Hollywood Boulevard and North Garfield Place in 1926. Close to the Louis B. Mayer Building, which housed the motion picture Hays Office and Central Casting, the St. Francis housed film industry people for decades. The neighborhood declined, but by 2002, the St. Francis had been remodeled into the Gershwin Hotel.

GARDEN OF ALLAH APARTMENTS, 1927. Designed like a bungalow court, this famous enclave was located at 8150 Sunset Boulevard in what is now West Hollywood. Part of actress Alla Nazimova's estate in 1921, the property was developed into this unusual complex where she and other residents could live. The first tenants were celebrities from the Hollywood colony who did not want to live in a house or were in Los Angeles temporarily. Throughout the 1920s and 1930s, lavish parties were thrown, frequented by the likes of Gilbert Roland, Errol Flynn, Clara Bow, Gypsy Rose Lee, Charles Laughton, Robert Benchley, and Leopold Stokowski. By the 1960s, the Garden of Allah had been demolished for a bank and strip mall.

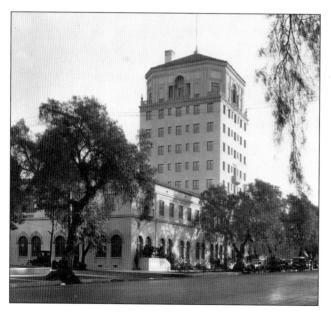

HOLLYWOOD ATHLETIC CLUB, 1926. In 1921, businessmen George Moore and Frank Galloway contemplated a local club based on the Los Angeles Athletic Club. This would be a social center for residents or visitors at a convenient location. A Hollywood Athletic Club was formed, initially with $150,000. The membership grew, and an elaborate facility was built on Sunset Boulevard at Hudson Avenue in 1923. The pool was a favorite of Olympian/action stars Johnny Weissmuller (Tarzan) and Larry "Buster" Crabbe (Flash Gordon). By 1926, the club had 1,000 members.

Five

HOLLYWOOD BOULEVARD

Prospect Avenue, with a trolley car system installed by 1900, was the east-west thoroughfare in the old Cahuenga Valley. One of the last official acts of the Hollywood Board of Trustees in 1910, before the annexation by Los Angeles, was to change the name of Prospect to Hollywood Boulevard. Other street names were changed too to honor Hollywood settlers: Beachwood Drive (named for Albert Beach), Cole Street (Sen. Cornelius Cole), De Longpre Avenue (Paul De Longpre), Gower Street (G. T. Gower), Ivar Avenue (Ivar Weid), Selma Avenue (Selma Weid), Wilcox Avenue (H. H. Wilcox), and others.

Tourists came to see De Longpre's mission-style estate when the only public buildings were the Sackett and Hollywood Hotels. In 1904, the Methodist Episcopal Church South was opened on the southeastern corner of Prospect Avenue and Vine Street, until it was replaced with the Taft building in 1923. In 1902, Charles Edward Toberman, a prominent pioneer developer, owned brick buildings on Prospect, housing his real estate businesses. In the 1910s, public buildings rising on Prospect included Los Feliz School, just west of Vermont Avenue; Idyl Hour Theater, Hollywood's first theater, located at 6525 Hollywood Boulevard in 1911; and the Hollywood Theater, which opened nearby on December 20, 1913. By 1907, Hollywood's first public library was on the northwest corner of Prospect and Ivar Avenue, and the Mason Temple building a block north of Prospect in 1904.

Between 1921 and 1931, Hollywood Boulevard sprouted a new skyline of office buildings, apartment houses, and hotels. The legal height limit was 12 stories, and developers took advantage of the maximum with the construction of the Taft Building (1923) at Hollywood Boulevard and Vine Street, B. H. Dyas Building (1928), Equitable Building (1930), Guaranty Bank Building (1925) at Ivar Avenue, Security First National Bank Building (1928) at Hollywood Boulevard and Highland Avenue, Hollywood Professional Building at Sycamore Avenue (1926), and Security Trust and Savings Building (1922) at Cahuenga Boulevard.

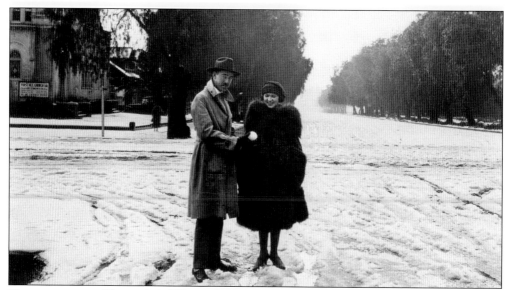

HOLLYWOOD AND VINE, 1919. When a freak snowstorm hit Hollywood, Paramount film director William Beaudine and actress Trudy Levee (married to studio executive and later agent Mike Levee) had their picture taken at Hollywood Boulevard and Vine Street. Behind them on the southeast corner is the Methodist Episcopal Church South, built in 1904. By 1924, the church site was developed into the Taft Building.

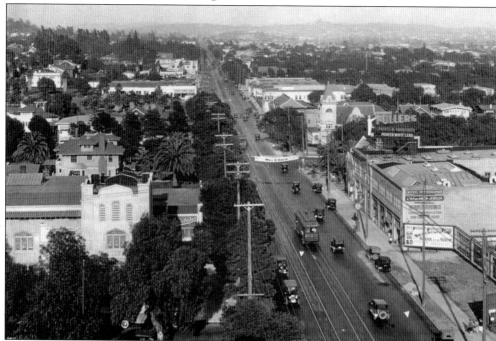

HOLLYWOOD BOULEVARD, 1922. An easterly view down Hollywood Boulevard toward Vine Street shows the First Methodist Church on the northeast corner of Ivar Avenue and Hollywood Boulevard, built in 1910. On the southeast corner of Hollywood Boulevard and Vine Street (center right with the pointed steeple) was the Methodist Episcopal Church South. At right, the Witzel Photography Company was a mainstay at that time.

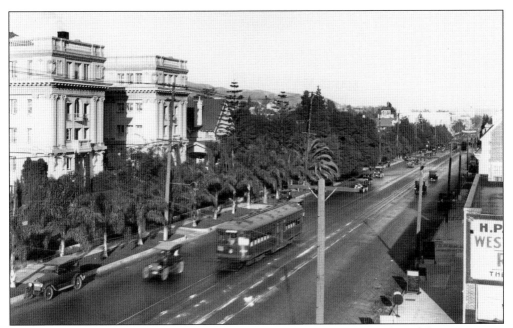

GARDEN COURT APARTMENTS, 1920. A view east on Hollywood Boulevard from Sycamore Avenue shows the Garden Court Apartments at left. "The Boulevard" was still semi-residential with some mansions still fronting the main street. Between 1920 and 1927, almost all residential buildings disappeared, replaced by commercial structures of all sizes.

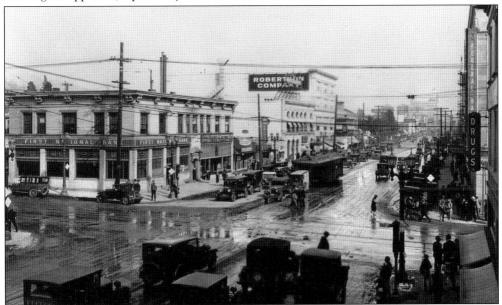

HOLLYWOOD AND HIGHLAND, 1923. The western end of Hollywood Boulevard began to develop when the Hollywood Hotel opened in 1903. The intersection of Hollywood Boulevard and Highland Avenue was the crossroads where most traffic passed to go through the Cahuenga Pass. On the north side of Hollywood Boulevard is the arched front building of the Montmartre Café, which opened in 1923. The First National Bank Building on the northeast corner would later be demolished and replaced with a high-rise that endures today.

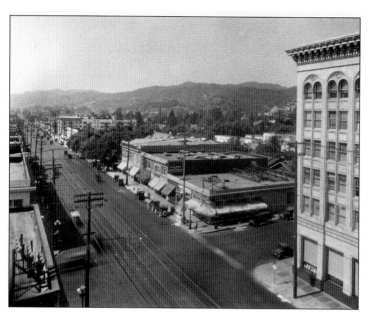

HOLLYWOOD AND CAHUENGA, 1922. On the northwest corner of Hollywood Boulevard and Cahuenga Boulevard was the first location of the Hollywood Athletic Club, which moved to Sunset Boulevard and Hudson Avenue in 1923. Hollywood Boulevard was a wide street, accommodating double-rail tracks and almost four lanes of traffic and curbside parking.

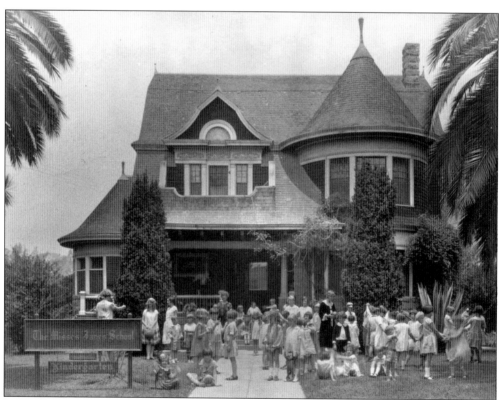

JANES HOUSE, 1920. The 1903 Janes House is one of only two remaining residential homes from Hollywood Boulevard's residential past. Operated as a private school by the three Janes sisters from 1911 until 1926, it was popular with the movie colony. Students included the children of Cecil B. DeMille, Charles Chaplin, Jesse L. Lasky, and Thomas Ince.

MASONIC TEMPLE BUILDING, 1922. Developed by Masons C. E. Toberman and Charles Boag in 1921 at a cost of $269,394, including land and furnishings, this building served as Hollywood's Masonic Lodge No. 355 for 60 years. It's most famous event was the memorial service held for legendary director and Mason D. W. Griffith, on July 28, 1948, attended by almost every major name in Hollywood.

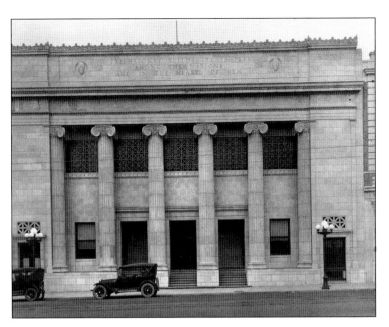

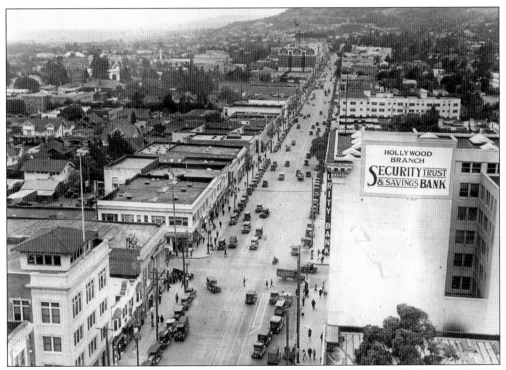

HOLLYWOOD BOULEVARD, 1925. Looking west down Hollywood Boulevard, this view depicts business activity that changed Hollywood into major economic center within 15 years. The once-sleepy, residential Hollywood Boulevard was alive with its bank buildings, restaurants, theaters, office buildings, and hotels and rivaled downtown Los Angeles at this time. Several tributaries of the Cahuenga River still flow under this part of Hollywood Boulevard.

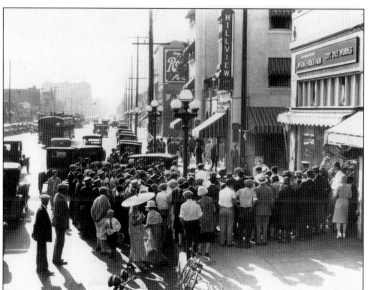

FILMING AT HILLVIEW APARTMENTS, 1925. Location filming has been a frequent occurrence in Hollywood from 1911 until today. This film crew shoots Harold Lloyd's *For Pete's Sake*. Filming was so common that by 1917 Hollywood banned street filming. But the ban was more or less ignored.

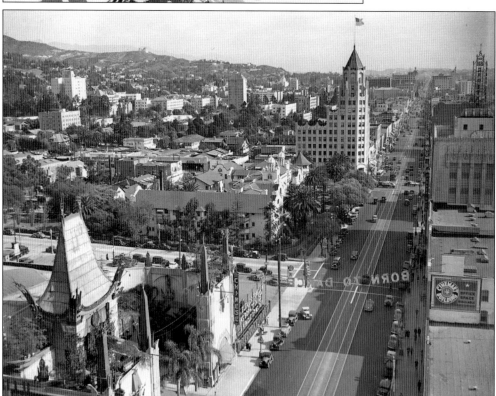

HOLLYWOOD BOULEVARD, 1937. Looking east from the Grauman's Chinese Theatre to the intersection of Hollywood Boulevard and Highland Avenue, this photograph was taken from the rooftop of the new Hollywood Roosevelt Hotel. It shows the western Hollywood Boulevard commercial corridor. The development here was led by C. E. Toberman, who helped create the Roosevelt Hotel, as well as the Chinese and El Capitan theaters (far right). He would later purchase the Hollywood Hotel (center) and demolish it for a project he was working on in the 1970s as he approached the age of 90.

HILLVIEW APARTMENTS, 1926. This apartment building at Hudson and Hollywood Boulevard opened in 1917 and was codeveloped by movie pioneer Jesse L. Lasky of the Lasky Feature Play Company. Not just an investment, the apartments were needed by the studios as housing for newly arrived actors who were not looked upon favorably by the local apartment owners. The building was recently restored.

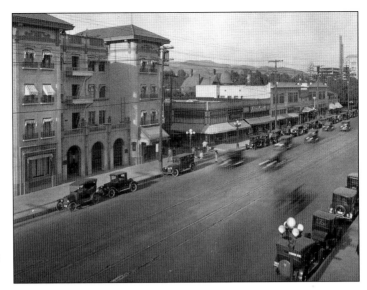

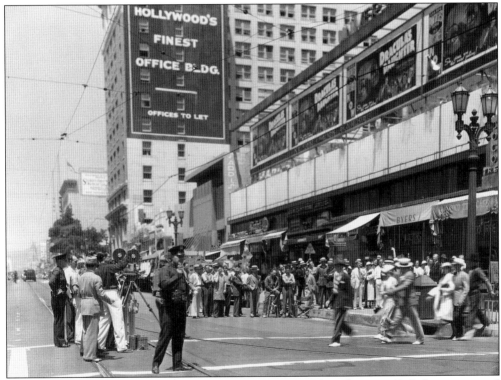

HOLLYWOOD AND VINE, 1936. Scenes from *Hollywood Boulevard* starring Bob Cummings and Marsha Hunt were filmed on the northwest corner of Hollywood's most famous corner. The Laemmle Building is at the right, designed by famed Modernist architect Richard Neutra. Carl Laemmle, founder and head of Universal Pictures, developed the site in 1933 for a Coco Tree Café. Plans for an office building and 900-seat theater changed because of the Depression. The 24-sheet movie posters on the Neutra-designed billboards plugged the latest Universal releases lighted with neon frames.

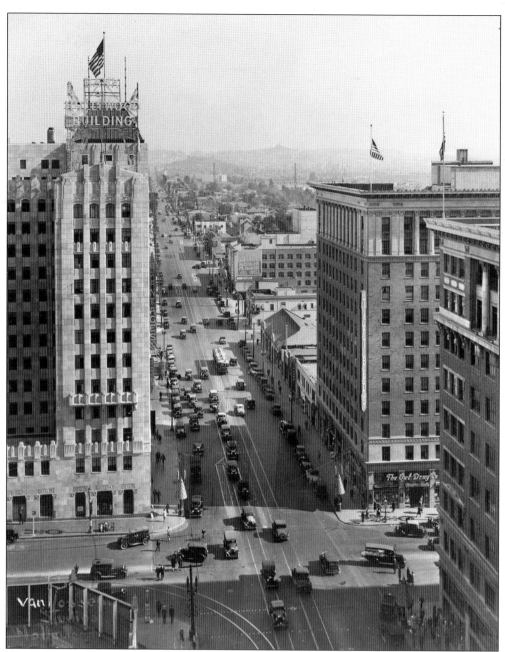

HOLLYWOOD AND VINE, 1931. An eastward view of the intersection of Hollywood Boulevard and Vine Street depicts development that altered Hollywood Boulevard in the 1920s. Its three height-limit buildings held to a dozen stories are the Equitable (left) northeast corner, the Taft (right) southeast corner, and the B. H. Dyas (far right) southwest corner. All are still landmarks today. Located on the northwest corner (bottom left) was the one-story Laemmle Building seen under construction here. Development plans eastward ended with the Depression in 1930, when the Pantages Theater Company cut off the 10-story office tower from its theater building. Plans were announced in 2007 to complete the Pantages Building by constructing the original planned 10-stories to the 1929 design.

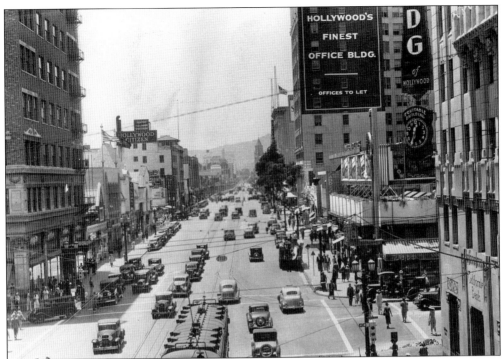

HOLLYWOOD AND VINE, 1936. This view looks westward down Hollywood from Vine Street, where the four-cornered landmarks of the Taft, Broadway, Equitable, and Laemmle/Neutra buildings. Hollywood was developed from the early 1900s to the 1930s as different "fingers," as the roads going north and south were called. The "western fingers," La Brea and Highland Avenues, primarily were controlled by Toberman interests. The "eastern fingers," including Ivar Avenue and Vine Street, were owned and developed principally by the Stern and Taft families.

VIEW FROM ARGYLE STREET, 1936. The Equitable Building on the right is basically a blank wall. This was a result of plans in 1930 to build a 10-story office building on top of the neighboring Pantages Theater, thus blocking any windows on the Equitable Building, which was also being built in 1930.

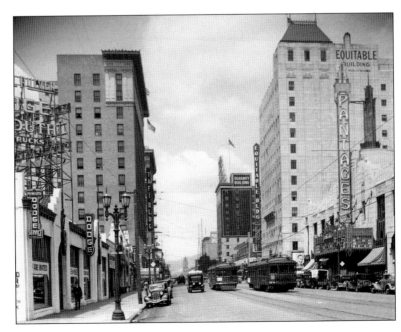

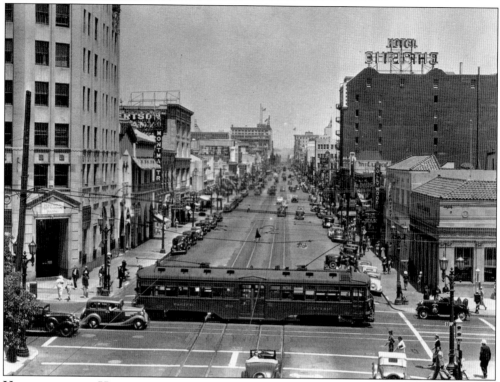

HOLLYWOOD AND HIGHLAND, 1936. The one-story 1914 Bank of America on the right had been reduced from four stories after the 1933 Long Beach earthquake. The top three residential floors were removed to strengthen the first floor and to save costs of seismic upgrading. Next door is the Hollywood Theater playing *Mr. Deeds Goes to Town*, starring Gary Cooper.

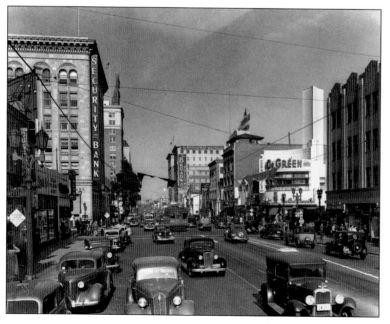

HOLLYWOOD AND CAHUENGA, 1939. This eastward view shows Hollywood at Cahuenga Boulevards with the Security Trust Bank Building at left, and the circular Streamline Moderne Dr. Green Dental Building to the right.

Six

HOLLYWOOD LANDMARKS
1920s–1930s

Hollywood in the 1880s thrived on citrus and vegetable crops when Harvey Wilcox subdivided land, creating business opportunities. The first Hollywood business was real estate, aided by the railways. In 1885, Cahuenga Valley got its first market and general merchandise store, located at Santa Monica Boulevard and Vine Street. Owner Alfred Watts moved the Hollywood Cash Grocery in 1888 to Sunset and Cahuenga Boulevards. He started the valley's first delivery service of groceries and mail. Between 1888 and 1900, other businesses moved into town, including Meyer (meat) Packing Company with semiweekly deliveries, Hollywood Ice Company (later Union Ice Company) preserving foods, and in 1887 Martin Labaig's Six Mile House, a somewhat 7-Eleven–style convenience store of its era at Sunset and Gower Street. The Sackett Hotel also included a general store. In 1889, Rene Blondeau purchased six acres at the northwest corner of Sunset Boulevard and Gower Street and built the Cahuenga House, also known as the Blondeau Tavern. When the film industry came to town, the tavern building, which had closed because of Hollywood Prohibition, became the first Hollywood film studio in 1911.

In 1889, the Farmers' League of Cahuenga Township formed to protect members from ruinous competition. Six years later, the Cahuenga Valley Lemon Growers' Exchange began to operate a communal packinghouse. When the Hollywood Hotel opened in 1903, it became commerce central for meetings. Farming-related businesses still thrived, including Sunset Livery and Stables. When studio facilities arrived, new jobs were created for filmmakers as well as drivers, cooks, carpenters, plumbers, builders, painters, office personnel, and extras, creating a need for housing. The first newspaper was the *Cahuenga Suburban* in 1895. The *Hollywood Citizen* was first published in 1905.

In June 1903, the Hollywood Board of Trade was formed. New businesses included Hollywood Tire Shop and Sun Drug Company, and the first two financial institutions were Highland Bank and Hollywood National Bank.

HOLLYWOOD AND VINE, 1920. This aerial view shows the Famous Players–Lasky Studios at Sunset Boulevard and Vine Street (bottom left), the back lot between Argyle and El Centro Avenues, and the Christie Studios at Sunset and Gower Street (bottom right). Hollywood Boulevard and Vine Street can be seen in the center-left of the photograph, with the Methodist Episcopal Church South on the southeastern corner (site of Taft Building) and Hollywood pioneer Jacob Stern's estate, located in the center of the citrus orchards (far left).

LAKE HOLLYWOOD, 1925. Located in Weid Canyon above the Hollywoodland development, the Hollywood Dam provided important resources. The chief engineer, William Mulholland, planned the dam with the residents in mind so that it would pose no threat to the community below. Work started in August 1923 and was completed in December 1924. The dedication was held on March 17, 1925, and the 200-foot-high dam has become a Hollywood landmark.

EAST HOLLYWOOD, 1922. This depiction of the intersection of Hollywood and Sunset Boulevards shows the Charles Ray Studios, now KCET-TV (left), and the Fine Arts Studios (center). The main thoroughfare at the bottom is Hollywood Boulevard where it ends. Sunset is in the center where it turns south toward downtown Los Angeles. The open ground to the far left was the site of D. W. Griffith's Babylon sets for his film *Intolerance* (1916).

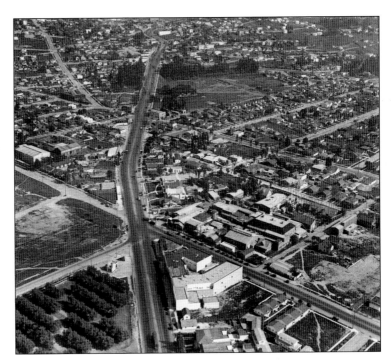

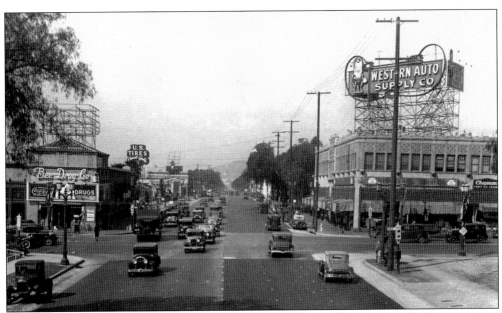

SUNSET AND VINE, 1930. For many years, Sunset Boulevard and Vine Street (looking west) was where one could find the Famous Players Lasky–Paramount Studios on the northeast corner. In 1926, Paramount moved to a new location at Melrose and Van Ness Avenues. At the time of this photograph, the old site was a parking lot and shortly thereafter a drive-in restaurant. On the northwestern corner was the Sunset and Vine Building, built in 1928. In 1940, Glenn Wallichs remodeled the old Sunset and Vine Building, and it was renamed Wallichs Music City. It is where he installed Capitol Records in 1942.

CHAMBER OF COMMERCE, 1934. When the chamber was formed in 1921, the first office was located at 6553 Hollywood Boulevard. It moved to 6530 Hollywood Boulevard in 1923 and to 6522 Sunset Boulevard in 1926. There it stayed until 1976. The chamber's first mission was to make Hollywood Boulevard the most exclusive shopping district in the West.

AMERICAN LEGION POST, 1930. When the American Legion Post No. 43 was first organized on August 16, 1919, the veterans met at a private residence at 1020 Cole Avenue. Between 1920 and 1929, they met at several locations, including Wilcox Hall and Toberman Hall, before land was bought at 2035 North Highland Avenue, down the block from the Hollywood Bowl. The reinforced concrete classical building was dedicated on July 4, 1929, and remains a notable landmark.

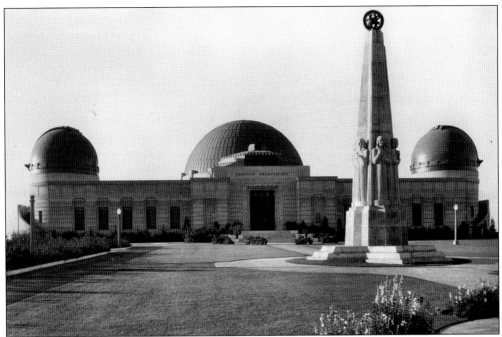

GRIFFITH OBSERVATORY, 1939. California pioneer Griffith J. Griffith willed his property in the hills above Los Feliz to the City of Los Angeles when he died in 1919. He stipulated that a Greek Theater be built along with an observatory and science hall on Mount Hollywood. After many delays, the city built the observatory between 1933 and 1935, and it remains an Art Deco landmark.

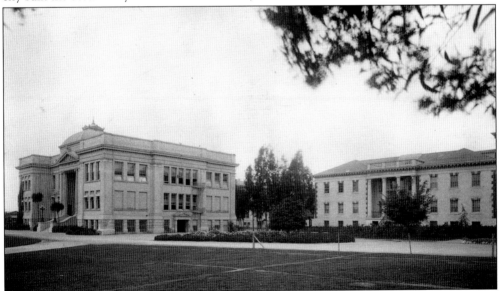

HOLLYWOOD HIGH, 1916. When Hollywood became a city in 1903, one civic project created Hollywood Union High School District. Classes had been meeting in the basement of the Masonic Temple on Highland Avenue. Union High School was completed in 1905. The main school classroom buildings, left, fronted on Sunset Boulevard, and at right was the Household and Fine Arts Building. Out of the photograph to the right was the auditorium near the northwestern corner of Highland Avenue and Sunset Boulevard, which still stands today.

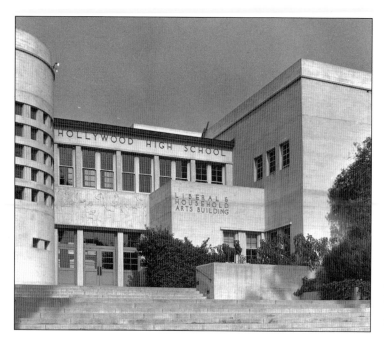

HOLLYWOOD HIGH, 1940. Located at the northwest corner of Sunset Boulevard and Highland Avenue, all but one of the original buildings of the campus were demolished by 1934 and replaced with new classroom facilities. Architects Marsh-Smith and Powell designed monumental Streamline Moderne buildings built by the Federal Arts Project; the one pictured has a bas-relief by Bartolo Mako over the main entrance.

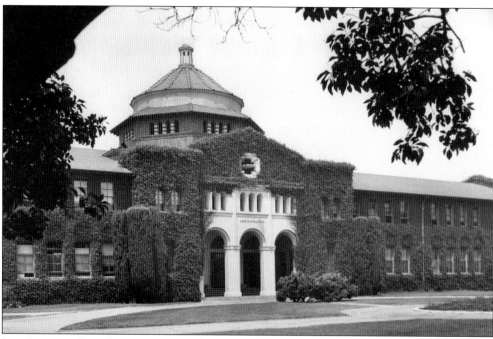

LOS ANGELES CITY COLLEGE, 1939. The State Normal School moved from its longtime location in downtown Los Angeles to Vermont Avenue in 1919. The name of the school was changed to the University of California at Los Angeles, and new buildings expanding the campus in the 1920s included a football and track stadium. By 1927, UCLA moved to its present campus at Westwood Village, leaving the Vermont Avenue campus to the newly organized Los Angeles City College. In 1927, during this transition, film comedian Buster Keaton directed *College* (1927) on location at the campus.

IMMACULATE HEART, 1930.
The original school was opened in 1905 by the Sisters of the Immaculate Heart of Mary at the northwest corner of Franklin and Western Avenues. By 1908, the campus was the first private school in Hollywood to receive college accreditation. In 1916, the organization of Immaculate Heart College was completed, and by 1927, a new college building was built near the curve of Western Avenue and Los Feliz Boulevard. The campus changed dramatically in 1929 when a three-story, main classroom building and a dormitory were included in an overall Moorish-mission design.

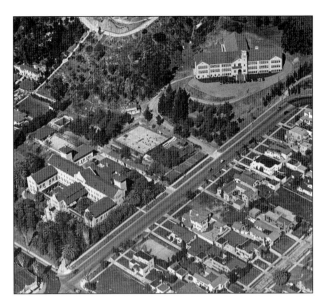

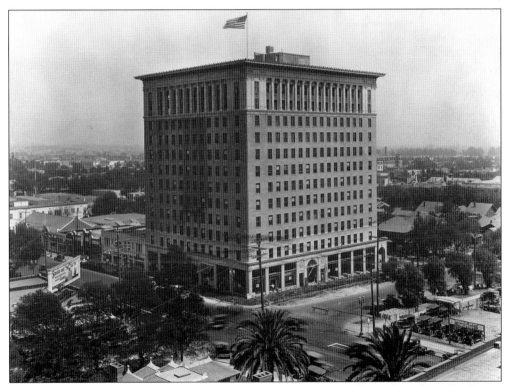

TAFT BUILDING, 1923. Located on the southeastern corner of Hollywood Boulevard and Vine Street, the 12-story Taft Building was the first height-limit office building in Hollywood on the site of the old Hollywood Memorial Church. The Taft opening was attended by boxer-actor Jack Dempsey and other celebrities during festivities lit at night by the Otto K. Oleson Company. The Taft Building was home through the 1960s to agencies, lawyers, dentists, radio agents, and theatrical unions.

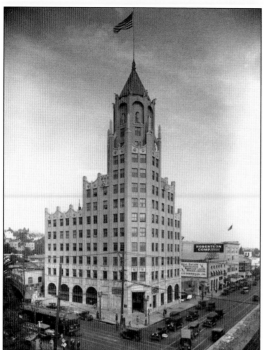

SECURITY FIRST NATIONAL BANK, 1928. The bank was the first 12-story office building constructed at Highland Avenue and Hollywood Boulevard. Built in 1928, the Los Angles First National Bank building was shortly thereafter changed into the Security First National Bank and became a Hollywood landmark, seen as one of three film locations used for the *Daily Planet* in the 1950s television show *Superman*. Bas-relief panels on the west and front sides of the building depict Nicholai Copernicus and Christopher Columbus, symbolizing enterprise and discovery.

LOUIS B. MAYER BUILDING, 1936. Officially opened by MGM star Norma Shearer in December 1928, the Mayer Building epitomized the film industry on eastern Hollywood Boulevard. Architect S. Charles Lee designed facade friezes named "The Spirit of Hollywood," symbolizing movie making. The first tenants in the building on the southwest corner of Western Avenue and Hollywood Boulevard were Central Casting and the Motion Picture Producers and Distributors Association (MPPDA). MGM top executives Louis B. Mayer and Irving Thalberg helped finance the building's construction.

EQUITABLE BUILDING, 1931. The third and last high-rise building built at the intersection of Hollywood Boulevard and Vine Street was the Equitable/California Bank Building. Completed in 1930, the building would house business- and entertainment-related service professions, such as lawyers, agents, and accountants. During the 1930s and 1940s, the building was the home to radio agents and producers such as Young and Rubicam and the Williams Esty and Company. Also advertising agencies affiliated with radio made the Equitable Building home.

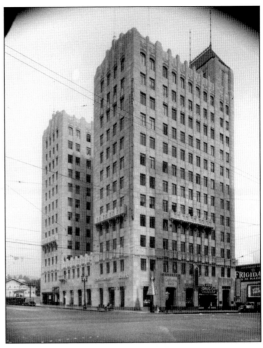

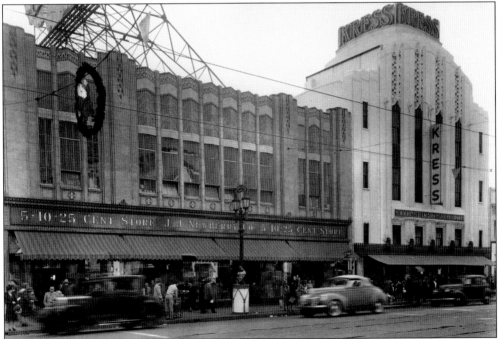

NEWBERRY AND KRESS BUILDINGS, 1937. The J. J. Newberry store was established in 1928 at 6600–6604 Hollywood Boulevard (at Whitley Avenue) in a landmark Art Deco–style building. Next door to the west was the S. H. Kress Building designed by Edward F. Sibbert in the Streamline Moderne style at 6606–6612. The Kress later became the famous lingerie store Frederick's of Hollywood. Both stores helped make Hollywood Boulevard an important shopping destination in architecturally historic buildings that epitomized Hollywood as the glamour capital.

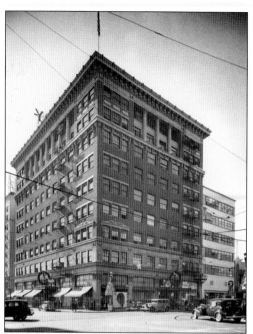

BROADWAY DEPARTMENT STORE, 1938. The second high-rise landmark building at Hollywood Boulevard and Vine Street was originally built by a group of businessmen and first leased to the B. H. Dyas Department Store, which opened March 11, 1928. By March 2, 1931, the lease on the building at 6300 Hollywood Boulevard was assumed by the Broadway Department Stores, whose headquarters were in downtown Los Angeles.

HOLLYWOOD CEMETERY, 1929. Established on Santa Monica Boulevard between Gower Street and Van Ness Avenue in 1899, the cemetery received its first late, very late, customer in 1900: Mrs. T. W. Price. The cemetery extended from Santa Monica Boulevard on the north to Melrose Avenue on the south. By 1915, the property was split to allow the southern half for varied uses. In 1917, the Paralta Film Company used it for a location lot. The cemetery became Hollywood Memorial in the 1940s and, recently, Hollywood Forever Cemetery. The film lot has been the home of Paramount Pictures since 1926.

Seven

REAL ESTATE AND MOVIE COLONY

The grand Victorian homes on Prospect Avenue (renamed Hollywood Boulevard in February 1910) in Hollywood from about 1900 to 1920 included the Hurd Mansion, Grass Residence, Wakeman Ranch, Taft House, Mary Moll House, Sanford Rich place, Janes sisters' house (which became Hollywood's first private school), De Longpre residence, Daeida (Wilcox) Beveridge home, and Jacob Stern residence on the southwest corner of Vine Street. Some of these more prominent estates included the A. G. Bartlett Estate; Arthur Letts Estates; Gurdon Wattles Estate; Dr. Schloesser's Glengarry Castle and his later Castle Sans Souci; and Ozcot, the residence of L. Frank Baum, the author of *The Wizard Of Oz* and related stories.

When movie people came to Hollywood, they lived near their studios. Cecil B. DeMille first leased a house in the mouth of the Cahuenga Pass and, by 1916, purchased a mansion in the Laughlin Park area of northeast Hollywood. Famed Japanese actor Sessue Hayakawa purchased Glengarry Castle, and it became one of the first movie star homes on the tourist circuit. Other stars followed, such as Francis X. Bushman, William Farnum, Lon Chaney, Conway Tearle, Charles and Sydney Chaplin, and producers Thomas Ince, Samuel Goldwyn, and Jesse L. Lasky, among many others.

Most movie stars first lived in Hollywood's hills, but by the 1930s had moved gradually to places like Beverly Hills. The apartment houses of Hollywood became plentiful, some of them high-class buildings, housing such stars as Mae West and George Raft. The older apartments, such as the Garden Court Apartments on Hollywood Boulevard, ended up derelict, but not before Keystone Comedy Studio founder Mack Sennett made the place his home in the early 1950s.

The largest residential land development was Hollywoodland. The subdivision encompassed 500 acres of rustic canyons minutes from downtown Hollywood. Located in the foothills of Beachwood Canyon, the development, headed by a group of investors including Harry Chandler of the *Los Angeles Times*, advertised the project with a white-faced series of advertising letters 50 feet high. The sign could be seen for miles around. By 1949, the L-A-N-D portion of the letters was taken down, leaving the sign as it is known today.

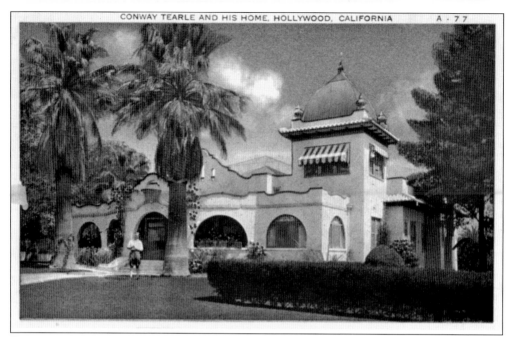

TEARLE HOME, 1921. One of the earliest Mission Revival homes in Hollywood was where silent-film star Conway Tearle lived. Built around 1905 and located at 1782 North Orange Drive at the corner of Orange and Franklin Avenue, the house was acquired by the A.S.C. (American Society of Cinematographers) in 1936 and is still their headquarters today.

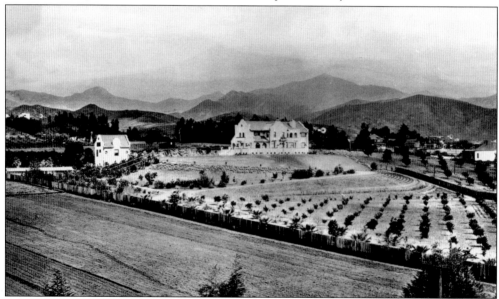

BARTLETT ESTATE, 1905. One of Hollywood's original 19th-century farms was located at what is now Yucca Street and Argyle Avenue. A. G. Barlett, a sheet music publisher, purchased the farm in 1901 in what was part of the Vista del Mar Tract with a commanding view of Hollywood. The mission-style house became a tourist attraction as early as 1905. A portion of the southern gardens survived and was acquired by the Hollywood Country Church in 1932, which originated church radio services.

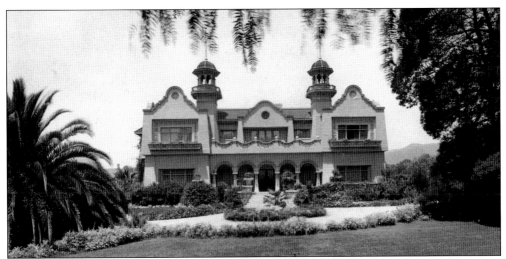

DE LONGPRE RESIDENCE, 1905. The first Hollywood tourist attraction was the Paul de Longpre Mansion at the northeast corner of Prospect and Wilcox Avenues. Famed flower painter, de Longpre came to Hollywood in the 1890s and built a Mission Revival mansion in 1901. When Hollywood tourism escalated, the de Longpre mansion became a stop for teatime and buying paintings. De Longpre died in 1911. The mansion survived as an apartment house in 1919, and was demolished in 1927 to make way for the new Warner Brothers Hollywood Theater.

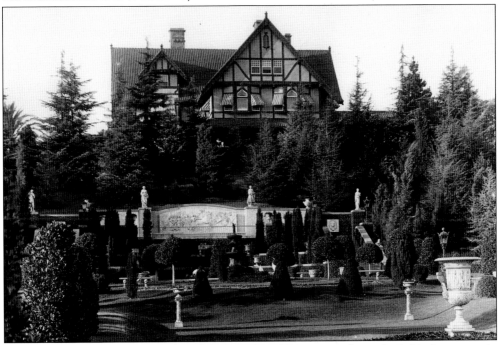

LETTS ESTATE, 1915. The founder of the Broadway Department Stores built his first estate in 1904 at Carmen Place, west of Gower Street. After living there for 10 years, Arthur Letts moved to a palatial estate on 40 acres at Franklin Avenue and Edgemont Street. Named "Holmb" after his birthplace in England, the mansion contained a library, music room, billiard room, and reception hall with a large, Gothic, stained-glass window. The Italian gardens contained cacti and tropical plants.

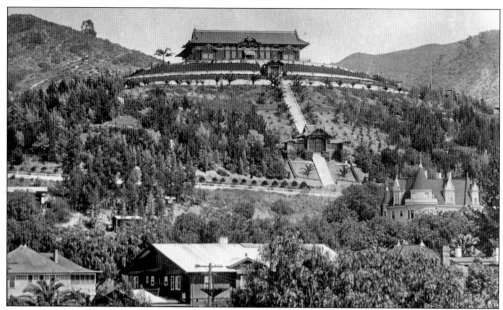

YAMASHIRO HILL, 1914. The Victorian mansion, right, was built by Rollin B. Lane and named Chateau Holly in 1909 by Mrs. Lane. Using the same plans devised for the Lane's Riverside home, the three-story, 17-room house became a landmark that was converted into the Magic Castle in 1961. Adolph and Eugene Bernheimer, New York importers of Oriental art objects, built the "Yamashiro" on the hill overlooking the Lane residence in 1912. It was sold in 1923 after the death of Eugene. Acquired by a private club, the property became the famed Yamashiro Restaurant in 1959.

Gurdon W. Wattles' ''Juanita,'' Hollywood, Cal.

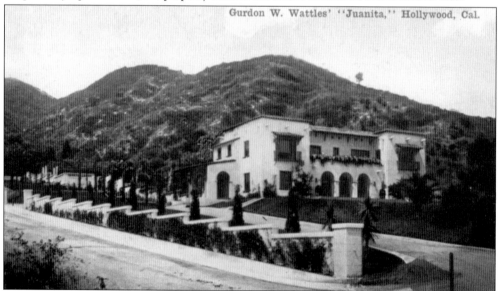

WATTLES ESTATE, 1910. This was built as a winter home named Jualita (incorrectly identified on the postcard) by Omaha financier Gurdon Wattles in 1907. He lived there until his death in 1932. The 90-acres extending from Hollywood Boulevard north to the Hollywood Hills' crest included Italian- and Japanese-themed gardens. Avocado trees survive today on the lower portions. The Wattles Estate's 100th anniversary was celebrated on June 3, 2007, by Hollywood Heritage, which restored the property.

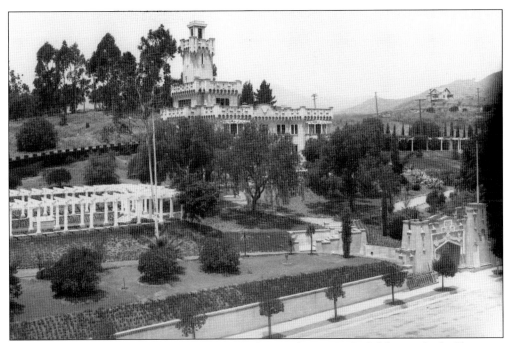

SANS SOUCI CASTLE, 1913. In 1909, retired Chicago doctor A. G. Schloesser built Glengarry Castle on the northeast corner of Franklin and Argyle Avenues. By 1912, he had built his dream castle, Sans Souci, on the northwest corner of Argyle and Franklin, designed after the castles of Germany's Rhine River Valley. Filled with European artwork, the castle was a tourist attraction into the 1920s.

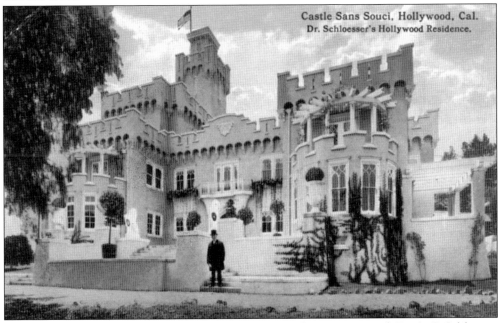

SANS SOUCI CASTLE, 1913. This is a color postcard of Castle Sans Souci with Dr. A. G. Schloesser standing in front of it. By the end of the 1930s, the castle was gone and had been replaced by the Castle Argyle Apartments, built in 1929.

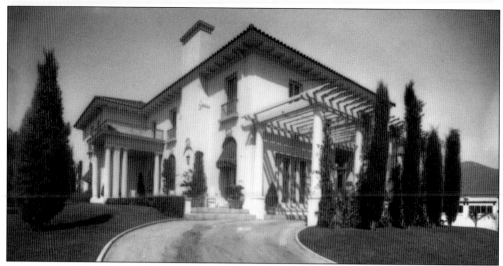

DeMille Estate, 1917. Cecil B. DeMille had lived in a bungalow house at the mouth of the Cahuenga Pass and later moved to Tamarind Street, just north of Hollywood Boulevard. In 1916, he purchased the former C. F. Perry Estate an Italian-style mansion in Laughlin Park. By 1917, DeMille acquired the neighboring W. J. Dodd estate and connected the buildings with a covered walkway. Later DeMille had the address changed to 2000 DeMille Drive. He used the Dodd house as his offices, screening room, guesthouse, and library. The main house was his primary residence until his death in 1959.

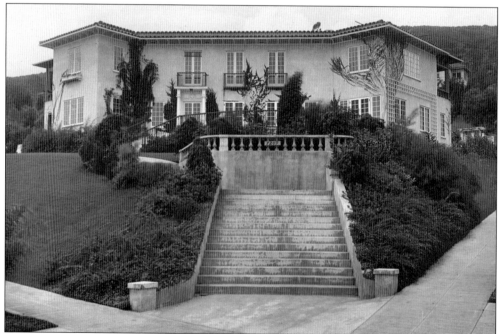

Lasky Estate, 1921. When the president of the Jesse L. Lasky Feature Play Company first came to Hollywood in 1914, he was to oversee with Cecil B. DeMille the filming output of Hollywood's first feature film company. He first stayed with DeMille and by 1915 moved into DeMille's former home. By 1916, he moved to a house on Hawthorn Avenue, and then in 1918, into an Italian-styled mansion at 7209 Hillside Avenue (at North La Brea Avenue).

90

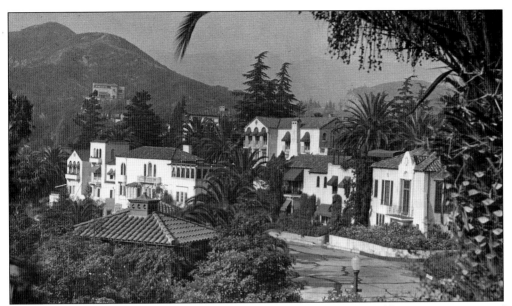

WHITLEY HEIGHTS, 1931. H. J. Whitley developed a tract north of Franklin Avenue just east of Highland Avenue originally named Whitley's Hill in 1904 and later Whitley Heights. The most prominent Whitley Heights resident was silent film star Rudolph Valentino, who purchased a house there in 1924, followed by Francis X. Bushman, Gary Cooper, and Janet Gaynor.

VALENTINO HOUSE, 1924. Rudolph Valentino and future wife Natacha Rambova purchased a house at 6776 Wedgewood Drive in December 1921. They waited for his divorce from a previous marriage before cohabitating. In February 1922, they moved into a seven-room, Spanish-style house on four lots with a view of the Cahuenga Pass. In 1925, Valentino, without Natacha, purchased a new home called Falcon Lair to the west in Benedict Canyon. By 1950, the Wedgewood Drive house and what was left of its contents were sold at public auction. The following year, the house was demolished for the new Hollywood Freeway.

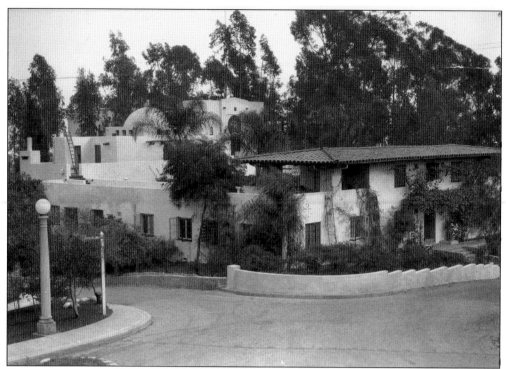

KROTONA INSTITUTE, 1925. In 1911, A. P. Warrington searched Hollywood for a home for the American branch of the Theosophical Society. He purchased the south slope of the hill between Argyle Avenue and Gower Streets at the intersection of Vista del Mar and Carmen Avenues. Here he erected several Moorish- and Spanish-style buildings. The center was named Krotona on the hill, which is where members built homes in similar Mediterranean styles. Public lectures were given Sunday afternoons, while adult courses concentrated on theosophy, astrology, and psychology. Hollywood celebrities such as Charles Chaplin and director Rupert Julien lived for times on Krotona Hill.

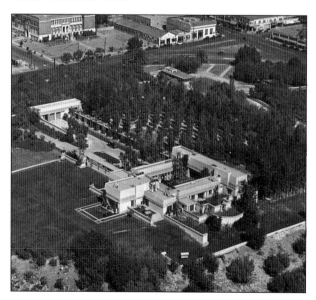

BARNSDALL PARK, 1924. On June 3, 1919, oil heiress Aline Barnsdall purchased Olive Hill, once the site of an olive grove owned by J. H. Spires. The 36 acres is bounded by Hollywood and Sunset Boulevards and Vermont and Edgemont Avenues. Barnsdall hired architect Frank Lloyd Wright to design her home and art gallery buildings. The home is named Hollyhock House after the flower. Barnsdall gave the City of Los Angeles a portion of the property. In 1946, Dorothy Clune Murray began converting of the property into an art center as Barnsdall wished. Today Barnsdall Park Art Center is operated by the city.

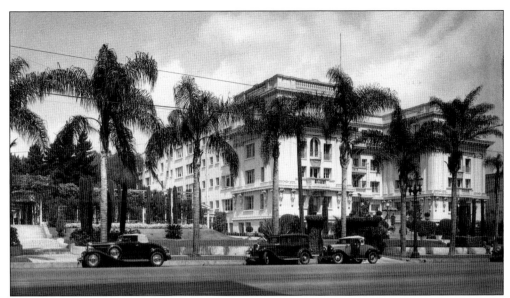

GARDEN COURT APARTMENTS, 1935. A display advertisement in the January 1, 1917, *Los Angeles Times* read, "The New Garden Court Apartments—The Most-Modern in the West, designed and erected by Frank Meline, designer and builder of all classes of buildings for Mr. and Mrs. J. E. Ransford." The four-story, 190-room, white-facade apartment house was planned in the Italian Renaissance design. There were two ballrooms, sumptuous suites with Oriental carpets, baby grand pianos, and fine oil paintings. The teak and mahogany apartments were reached by an ornately carved mahogany staircase. The building's portico entrance was guarded by caryatids holding up pilasters above the first story, one of which is at the Hollywood Heritage Museum. Demolished in 1984, the building's tenants included John Gilbert and Mack Sennett.

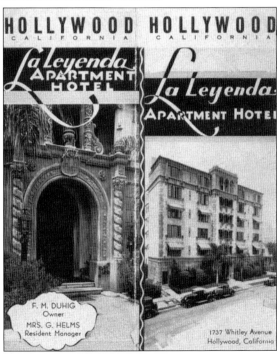

LA LEYENDA APARTMENT HOTEL, 1930. La Leyenda, at 1737 Whitley Avenue, was touted as "Hollywood's Exclusive Apartment Hotel" when it opened in 1927. The building's overall style is a combination of Spanish colonial and Italian Renaissance. Classified advertisements publicized the place as "Hollywood's Finest. Most homelike apartments in Hollywood." La Layenda's tenants were mentioned in the *Los Angeles Times* social register into the 1930s. F. M. Duhig, owner in the 1930s, advertised it as convenient, a "minute's walk to famous Hollywood Boulevard."

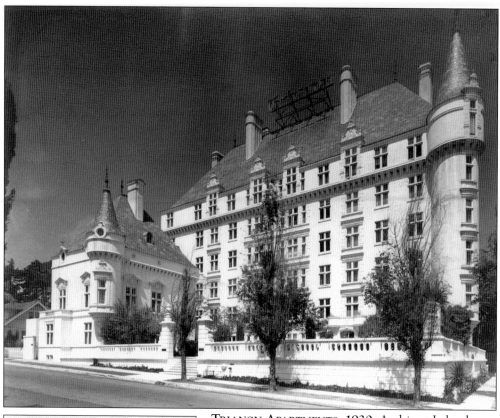

TRIANON APARTMENTS, 1930. Architect Leland A. Bryant created one of his masterpieces in the Trianon at 1750–1754 North Serrano Avenue in East Hollywood. The six-story, French Normandy building, with its neon roof sign, is distinguished by a round, conically roofed tower, a steep-hipped slate roof and dormers with narrow windows. In 1995, the building was declared Historic Cultural Monument No. 616. It was said that Douglas Fairbanks lived at the Trianon around 1934–1935 after his separation from longtime wife Mary Pickford.

MONTECITO APARTMENTS, 1931. Designed by architect Marcus P. Miller, the Montecito was Art Deco with zig zag motifs and windows in vertical bands featuring applied ornament in flora and fauna. Located at 6650 Franklin Avenue on the southwest corner of Cherokee Avenue, the apartment became a Hollywood landmark overlooking Hollywood Boulevard. Mystery writer Raymond Chandler supposedly modeled his fictional Chateau Bercy after the Montecito for *The Little Sister*. Tenants included Ronald Reagan and James Cagney.

CHATEAU ELYSEE, 1938. This residential apartment hotel was opened in 1929 by Eleanor Ince, the widow of motion picture producer Thomas H. Ince, who died in 1924. Designed by Arthur E. Harvey and located at 5930 Franklin Avenue on the southwest corner of Bronson Avenue, the site was originally the Ince family estate. Designed in the French Normandy Chateau style, there are 77 apartments varying from small, one-bedroom affairs to a two-story, three-bedroom space. The house operated as an apartment-hotel with a dining room serving three meals a day. In 1987, the Chateau was declared Historical Cultural Monument No. 329.

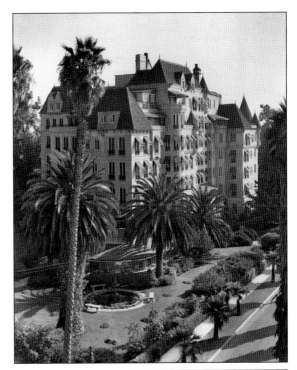

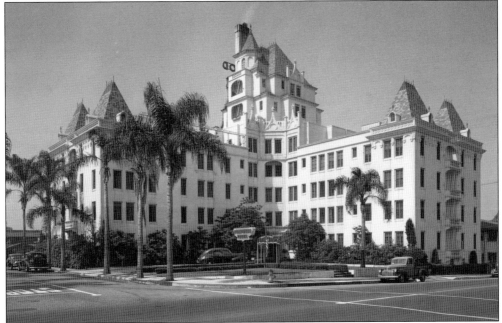

HOLLYWOOD TOWER, 1940. One of Hollywood's most prominent apartment buildings is the Hollywood Tower at 6200 Franklin Avenue. Architects Cramer and Wise designed a French Normandy Chateau–style building completed in 1929. It has been characterized by the builders as being a place of "Sophisticated living for film luminaries during the Golden Age of Hollywood." George Raft had an interest in the building and lived there for a time. The Hollywood Tower was registered on the Register of Historic Places by the U.S. Department of the Interior.

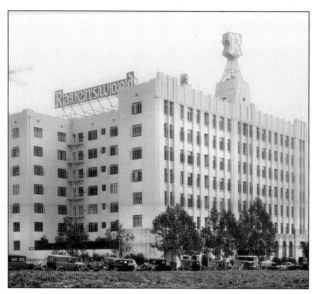

Ravenswood Apartments, 1936. Built in 1930 just before many Hollywood investors went bankrupt after the Wall Street Crash, the Ravenswood became a tourist attraction when Mae West moved here in 1932. Located at 570 North Rossmore Avenue, it was a mile from West's employer, Paramount Studios on Melrose Avenue. West's two-bedroom apartment had white décor with French gilt furniture. She stayed there until 1980. Designed by architect Max Maltzman in deco-Spanish/zig zag, the Ravenswood was declared Historic Cultural Monument No. 768 by the City of Los Angeles.

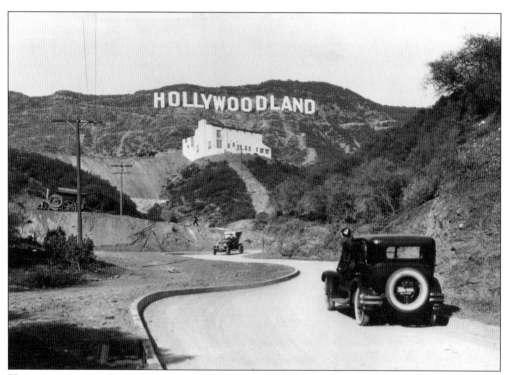

Hollywoodland Development, 1923. The concept of the Hollywoodland development was defined as "Living in the Hollywood Hills—the ultimate privilege." In 1923, Hollywoodland owners Harry Chandler, publisher of the *Los Angeles Times*, and Moses H. Sherman, director of the Pacific Electric Railway, began developing upper Beachwood Canyon. S. H. Woodruff and his partner, Tracy E. Shoults, were brought in to market and codevelop the residential project, the largest in Hollywood's history. Chandler's idea for a large advertising sign took the form of 50-foot-high sheet metal letters painted white, which could be seen for miles around.

Eight

RADIO DAYS

The Hollywood studios became interested in the fledgling radio industry as a new advertising method. In 1922, three radio stations came to Hollywood. Then KNX, a newspaper promotion tool and later a publicity vehicle for Studebaker automobiles, established a studio in 1924 at 6116 Hollywood Boulevard. The same year, KMTR opened a studio on Wilcox Avenue and later moved to the top of the Hollywood Storage tower at Highland Avenue and Santa Monica Boulevard. KMTR built a studio on Cahuenga Boulevard, and it later became the KLAC Studios. Harry Chandler's KHJ was used at first as promotion and advertising for the *Los Angeles Times.* By 1927 it was sold to radio pioneer and auto dealer Don Lee. Later the station was acquired by CBS and was located in several sites around the Hollywood area.

KFI was founded by automobile dealer Earl C. Anthony, who pioneered music and educational programming and was the first to broadcast from the Hollywood Bowl. In 1927, KFI became a part of the NBC Red Network, remaining a popular station for decades. The Warner Brothers founded station KFWB in 1925 in its administration building at Warner Sunset Studios on Sunset Boulevard, between Van Ness and Bronson Avenues. By 1928, it was located in the new Warner Hollywood Theater at Wilcox and Hollywood Boulevards. Giant radio towers were installed on each corner on the theater's roof, making it a landmark. By 1938, Hollywood originated 90 percent of the personality radio programs in the United States.

In 1938, the Columbia Broadcasting System/KNX radio built a state-of-the-art radio studio on the site of the Nestor Studios, the first motion picture studio in Hollywood, on the northwest corner of Gower Street and Sunset Boulevard. CBS's West Coast flagship station endures to this day. Nearby at Sunset and Vine Street, NBC built its state-of-the-art station, making Hollywood the West Coast radio center. Built on the site of the original Jesse L. Lasky Feature Play Company/ Paramount studio, it dominated the northeast corner of Sunset Boulevard and Vine Street as a true Hollywood landmark from 1938 to 1963. No radio stations have been located in Hollywood since 2006.

WARNER BROS./KFWB STUDIOS, 1929. In 1920, the Warner Brothers built their own studio on Sunset Boulevard between Van Ness and Bronson Avenues. The neo-classical style administration building became one of Hollywood's most enduring landmarks. In 1925, the Warners formed radio station KFWB—Keep Filming Warner Brothers— in the Sunset Boulevard administration building, adding two 100-foot-plus transmitting towers. Only one still exists in 2007, on the southwest corner of Van Ness Avenue and Sunset Boulevard.

KFWB HOLLYWOOD, 1936. The Warner Brothers started their own radio station to help augment national publicity for their film output. All the Warner stars were obliged to appear on KFWB to promote the latest film or themselves on the radio. Here we see, left to right, Warner stars Frank McHugh, Pat O'Brien, Dick Powell, and Robert Armstrong in front of the KFWB microphone. Photographs were printed in movie magazines around the world.

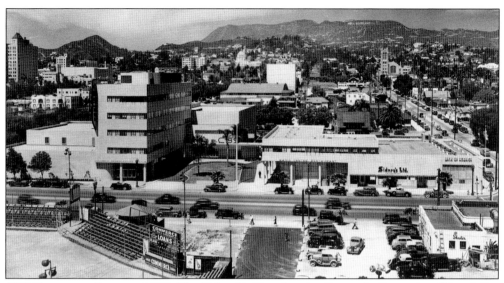

CBS COLUMBIA SQUARE, 1939. The Columbia Broadcasting System built a multimillion-dollar studio facility named Columbia Square, on the northwest corner of Sunset Boulevard and Gower Street in 1938. Designed in the international Moderne style by architects William Lescaze and E. T. Heitschmidt, their radio station, KNX, became the West Coast flagship station. The Gower and Sunset site of Columbia Square was originally where the Nestor Film Company opened the first motion picture studio in Hollywood. Sunset Baseball Field is at lower left.

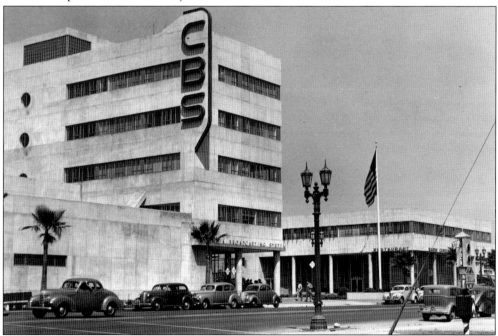

CBS COLUMBIA SQUARE, 1940. The CBS Columbia Square studios at 6121 Sunset Boulevard have been an enduring Hollywood landmark since it opened on April 30, 1938—almost 70 years. Seen from El Centro Avenue, the studio facility housed a large radio theater, six studios, executive offices, CBS management, the Artists Bureau, and a Bank of America adjacent to the Brittingham's Radio Center Restaurant. CBS radio left in 2006, and television in 2007.

CBS RADIO—KNX, 1935. Zazu Pitts appears on KNX Radio promoting her latest film, *Ruggles of Red Gap* starring Charlie Ruggles and Charles Laughton for Paramount. Pitts began her career as a supporting player for Mary Pickford and became a respected leading actress when she appeared in Erich Von Stroheim's *Greed* in 1924. With the advent of sound, she became a comedienne and worked at the Hal Roach Studios with Thelma Todd. She became famous with her zany and bewildered comedic line, "Oh Me! Oh My!"

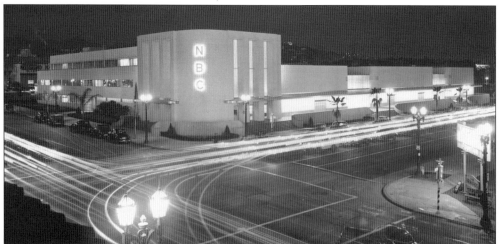

NBC RADIO CITY, 1938. The National Broadcasting Company's state-of-the-art studio facility was built on the northeast corner of Sunset Boulevard and Vine Street. NBC bought the site of Famous Players Lasky-Paramount Studios and had architect John C. Austin design the studio in the Streamline Moderne style. The facility, with its eight studios and executive offices, was finished in a blue-green color with an aluminum roof trim. The three-story lobby had a curved mural covering the northeast wall. It portrayed the "Genie of Radio" with his feet on Earth and head in the clouds amid scenes of radio broadcasts from around the world. Radio City was razed in 1963.

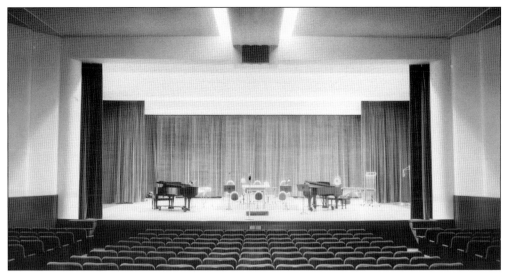

RADIO CITY STUDIO A, 1938. This studio opened on October 2, 1938, with NBC's *Carnival* starring Charles Boyer. The state-of-the-art studio with its control rooms attached, were separated with floating walls to reduce the vibrations. The color scheme of the studio theater included brown tints, sea-foam blue seats, copper-rose carpets, a turquoise front curtain, and an egg-blue rear curtain. This studio theater was the highlight of the complex.

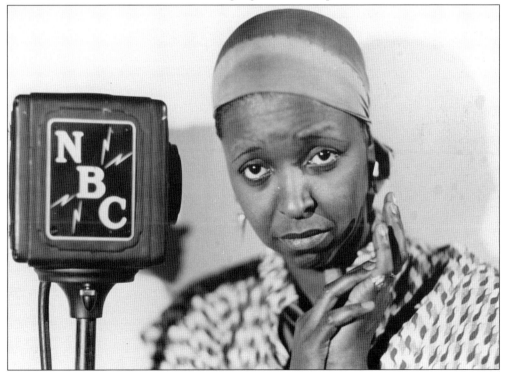

WATERS ON NBC, 1934. Ethel Waters talks about and sings songs from her latest film, *The Gift of Gab*, made at Universal in 1934. The radio studio was located then in the rehearsal hall on the RKO Studio lot on Melrose Avenue and Gower Street. Waters was the first black woman to receive star billing on the American stage and screen.

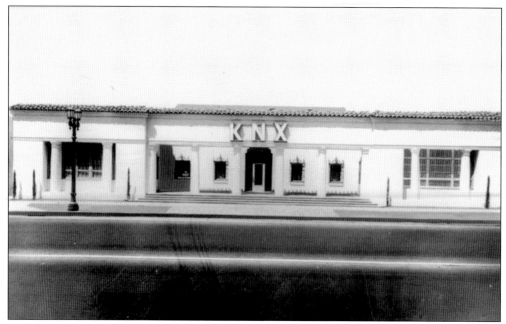

CBS/KNX RADIO STUDIO, 1936. When CBS purchased KNX radio, the station moved to a building at 5939 Sunset Boulevard that had housed Hollywood's first motion picture museum in 1928. CBS remodeled the building into a radio facility in 1932, designed by architect Earl Heitschmidt and decorated by the W&J Sloane Company. Studio A doubled as the main entrance lobby. Studio B was a Streamline Moderne–style soundproof studio with a retractable pipe organ. The building later became the Max Reinhardt School of Acting, followed by radio station KMPC, and then was purchased by Gene Autry. In the 1970s, it became the Spaghetti Factory Restaurant.

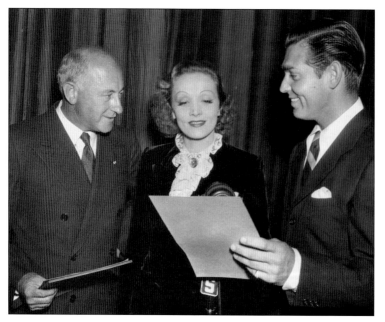

CBS LUX RADIO THEATRE, 1936. Famed film director Cecil B. DeMille produced and directed the Lux Radio Theatre for almost a decade exploiting the talents of many Hollywood stars. Here is DeMille with Marlene Dietrich and Clark Gable at the first broadcast on June 1, 1936, of the *Legionnaire and the Lady* over the CBS Radio Network from the Hollywood Music Box Theater.

CBS Lux Radio Theatre, 1939. The Lux Radio Theatre when it first came to Hollywood from New York City in 1936 was located at the Music Box Theater and by 1939 was moved to the Vine Street Theater. Cecil B. DeMille was the producer-director of the series that broadcast for two decades. In this image, Laurence Olivier and Vivien Leigh are standing in front of the Vine Street Theater when Olivier was appearing in the Lux Radio Theatre production of *Good Bye, Mr. Chips* that aired on November 20, 1939.

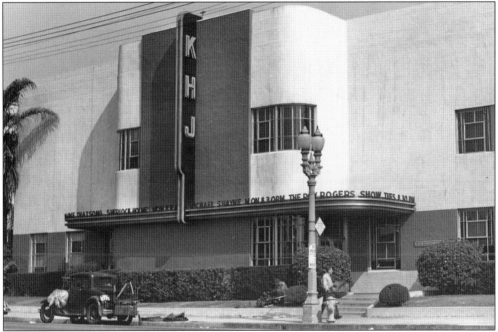

KHJ Radio Studios, 1945. Originally, this building was the Rothacker and later Consolidated Motion Picture Laboratories at 5515 Melrose Avenue. In 1935, NBC moved its first West Coast studio here from the neighboring RKO lot. By 1938, the Don Lee Broadcasting studios of KHJ took over. The KHJ operation occupied the studio until 1946, when NBC returned to open one of two television studios, which operated from 1947 to 1952. The other one was at the NBC Sunset and Vine Studios: KNBH-TV. In June 1951, Capitol Records opened a recording studio in the basement. Frank Sinatra recorded the songs here that started his 1950s comeback. Nat King Cole's classics *Mona Lisa* and *Nature Boy* were recorded here. In later years, the building housed KCAL-TV.

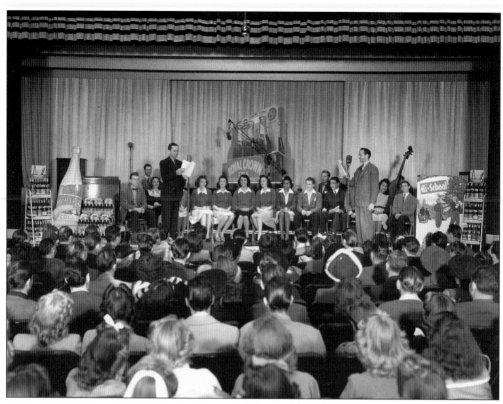

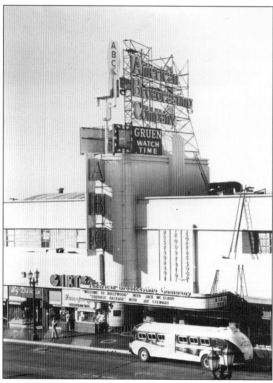

KHJ RADIO STUDIO, 1942. The *Royal Crown Cola High School Show* broadcasted in the KHJ Melrose Studios in Hollywood. KHJ catered to the local community and became a very popular station. For such a small building, the studio theater accommodated audiences up to a couple of hundred people.

ABC RADIO STUDIO, 1950. The Hollywood Recreation Center was built here in 1935 and converted to a radio studio for Tom Breneman's *Breakfast in Hollywood* show, which aired until his death. The studio at 1539 Vine Street was taken over by the newly organized American Broadcasting Company in 1949. When ABC moved here, the resident shows became *Welcome to Hollywood* with Jack McElroy and *Surprise Package* with Jay Stewart. The building became the Merv Griffin Theater in 1975, where *The Merv Griffin Show* was broadcast for many years and *Wheel of Fortune* originated.

Nine

DEPRESSION YEARS

The Great Depression technically began on October 29, 1929, but it didn't affect Hollywood until 1930, when plans to complete the Hollywood Pantages Theater office tower were curtailed, and Carl Laemmle, president of Universal, scrapped plans to build a high-rise theater and office tower on the northwest corner of Hollywood Boulevard and Vine Street. Coincidentally all the film studios were retooling their facilities for sound film production. Gradually the Depression closed some banks and businesses, and many of the original developers either lost everything or drastically curtailed projects. The Hollywoodland Development Company residential project suspended operations, as did other real estate projects.

The studios were still making many films, and people were still going to the theater. The Hollywood Brown Derby opened on February 14, 1929, about eight months before the stock market crash. Within those eight months, the Derby became a great success that the Depression couldn't close. The Chinese Theater premiered Howard Hughes's *Hell's Angels* in 1930 with thousands of fans lining the streets. But by 1932, the effects of the Depression took its toll as some studio properties were abandoned, while the major studio lots were consolidated to run more efficiently.

The Hollywood retail community also suffered by 1932. Some major stores closed, including Dyas Department Store at Hollywood Boulevard and Vine Street. Several theaters closed because of a lack of audiences. It was also at this time that Peg Entwhistle, an RKO actress despairing over a stalled film career, committed suicide by jumping off the Hollywoodland sign. Stores and buildings on Hollywood Boulevard were remodeled into new styles and designs such as Churrigueresque, a lavish and popular type of Spanish Baroque, and Art Deco. Despite some business downturn, the Hollywood Boulevard Business Association promoted Hollywood as the "World's Largest Department Store." Between 1935 and 1939, Hollywood recovered from the Depression by luring thousands of people to town with a new attitude of prosperity and optimism.

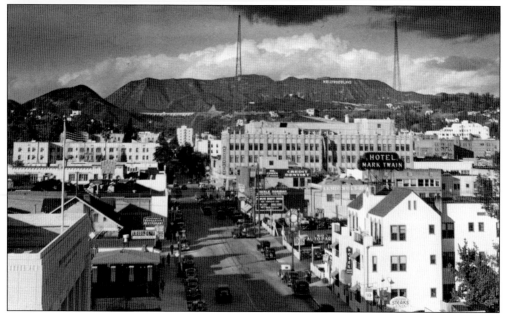

WILCOX AVENUE, 1937. Looking north up Wilcox Avenue from Selma Avenue, the Hollywood Post Office can be seen at bottom left. The Hollywoodland sign stands out as a landmark over Hollywood. At the bottom right is the Mark Twain Hotel, one of the many small hotels in Hollywood at the time that served the thousand of visitors coming to Hollywood as tourists or looking for some kind of job in the entertainment industry.

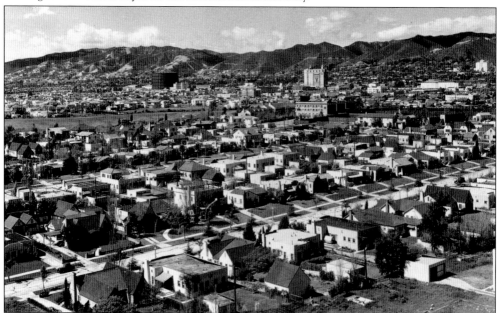

LILLIAN WAY, 1930. A view of Hollywood from Lillian Way just south of Melrose Avenue shows in the distance the gas storage tank at La Brea Avenue and Santa Monica Boulevard and the Hollywood Storage Company tower at Highland Avenue and Santa Monica Boulevard. Residential development in Hollywood during the 1930s was due to strong motion picture production and a surplus of motion picture workers and external studio services in the Hollywood area at the time.

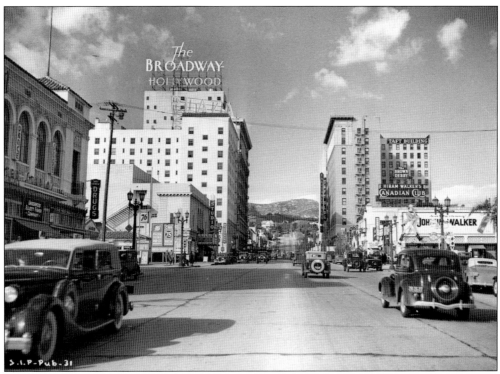

VINE STREET, 1937. At the far left, the Associated Studios of Dance Building, formerly the Hollywood Rooftop Ballroom, is seen on the southwest corner of Selma Avenue and Vine Street. North on Vine on the left is the former Vine Street Theater, which was renamed the Studio Theater, featuring film star Cary Grant in a play. Next door on Vine is the Plaza hotel, on the southwest corner of Hollywood Boulevard is the Broadway Hollywood, and across the street is the Taft Building on the southeast corner of Hollywood and Vine. Note the Brown Derby sign above the Canadian Club billboard.

PAN PACIFIC AUDITORIUM, 1940. Originally built as part of a major exposition complex in Gilmore Island bounded by Beverly Boulevard and Fairfax Avenue, the auditorium was one of several major sports and entertainment buildings built in the late 1930s beginning with the Farmer's Market built in 1934 and followed by Gilmore Stadium in the same year. Next came Pan Pacific Auditorium (1935), Gilmore Field (1939), Pan Pacific Theater (1946), and the Gilmore Drive-In (1948). All were gone by 1989.

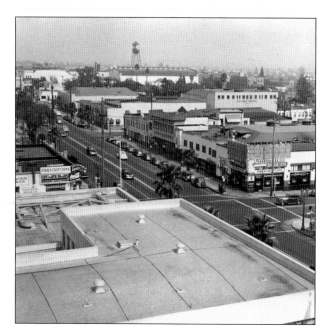

SUNSET BOULEVARD AND GOWER STREET, 1939. This photograph was taken from the rooftop of the CBS Columbia Square on the northwest corner of Gower Street and Sunset Boulevard. On the southeast corner was the Columbia Drug Company adjacent to the Columbia Studio south on Gower Street. Beginning on the southeast corner looking east from Columbia Drugs was the Hollywood Film Enterprises Laboratory and the Jerry Fairbanks Studio-Paramount Shorts at Beachwood Drive. Warner Brothers Hollywood Studio can be seen top-left with its water tower rising above the studio on Bronson Avenue.

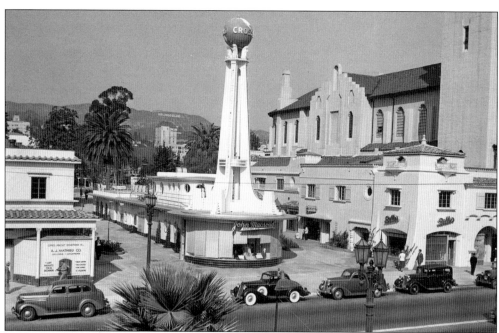

CROSSROADS OF THE WORLD, 1937. Located at 6671 Sunset Boulevard (at Las Palmas Avenue), this shopping, café, and office complex is unique with its eclectic style and layout. Designed by architect Robert V. Derrah for owner Ella Crawford in 1936, the complex became a Hollywood landmark almost immediately. Its unique design is laid out in the form of a ship in the marine-Moderne style, surrounded with various European structures such as Italian, French, English, Spanish, Turkish, Mexican, and Moorish styles as well as, on Selma Avenue, Cape Cod–lighthouse style. Declared a Historic Cultural Monument on December 4, 1974, the Crossroads continues to be a popular landmark.

MAX FACTOR HOLLYWOOD MAKEUP STUDIO, 1938. Factor opened his Hollywood Makeup studio and laboratories at 1660 North Highland Avenue in 1928 in a warehouse he bought from developer C. E. Toberman. In 1935, architect S. Charles Lee remodeled the building into a Regency Moderne–style showplace. Factor was marketing his new Color Harmony make-up products for "the average woman." Some very non-average women helped out. Jean Harlow dedicated the Blonde Room, Claudette Colbert the Brunette Room, and Ginger Rogers the Red Head Room.

HOLLYWOOD AND HIGHLAND, 1939. Below is Hollywood Boulevard and Orchid Avenue with Grauman's Chinese Theater at the bottom-left. The Hollywood Hotel, center, opened in 1903. On the northeast corner of Hollywood Boulevard and Highland Avenue is the Security First National Bank tower, built in 1928. On the right is the El Capitan Theater in the Barker Brothers Furniture Building, which reopened as a movie theater in 1942. The Hollywood Hotel site is currently the site of the Hollywood-Highland Shopping Center, where the Academy Awards are held in the Kodak Theater.

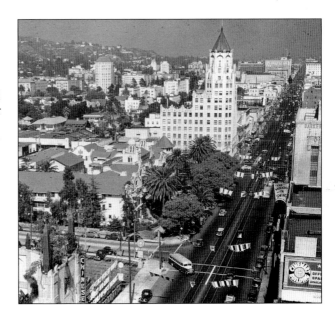

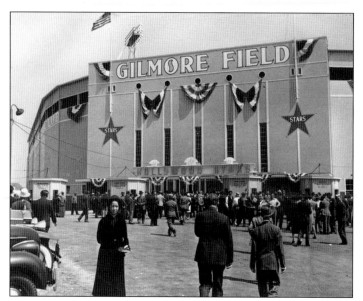

GILMORE FIELD, 1939. This was the home field of the Hollywood Stars of the Pacific Coast league from 1939 to 1957. Gilmore Island landmarks included the field stadium (1934), Pan Pacific Auditorium (1935), and Farmer's Market (1934). The Hollywood Stars were owned by Bob Cobb of the Brown Derby Restaurant in 1952 and became the site of CBS Television City, at Beverly Boulevard at Fairfax Avenue.

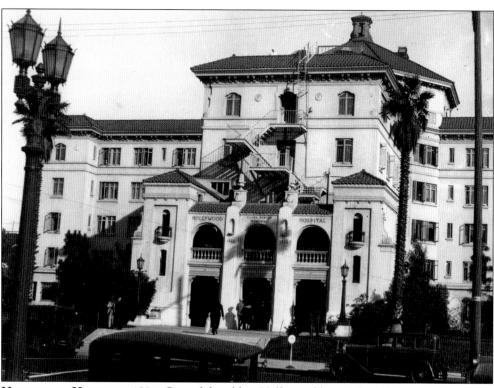

HOLLYWOOD HOSPITAL, 1931. One of the oldest Hollywood hospitals still in operation, it was dedicated as the Clara Barton Memorial Hospital in 1924. Located at 1322 North Vermont Avenue, the complex was the only major hospital center for miles around. When Hollywood Hospital was in financial difficulties during the Depression, it was bailed out by a $500,000 trust left by Millicent Olmsted. The Olmsted Memorial Trust took control of the hospital in 1937 and changed the name to the Hollywood Presbyterian Medical Center.

CHILDREN'S HOSPITAL, 1938. Established in Los Angeles in 1901, Children's Hospital was moved in 1906 to four acres owned by Emma Phillips at 4614 Sunset Boulevard (at Vermont Avenue). On February 7, 1914, the new Children's Hospital of Los Angeles at 4650 Sunset Boulevard was opened by Pres. Woodrow Wilson via telegraph from Washington, D.C.

CEDARS OF LEBANON HOSPITAL, 1939. Originally in Boyle Heights, this institution started out as the Kaspare Cohn Hospital in 1902. It moved around over the next decade and was later merged with Mount Sinai Hospital by the end of the 1920s. The merged entity moved to 4833 Fountain Avenue and into an Art Deco building at Berendo Street. In 1976, the new Cedars-Sinai Medical Center opened on Beverly Boulevard near West Hollywood where the first patients were moved. The Church of Scientology currently owns and operates the landmark Fountain Avenue building.

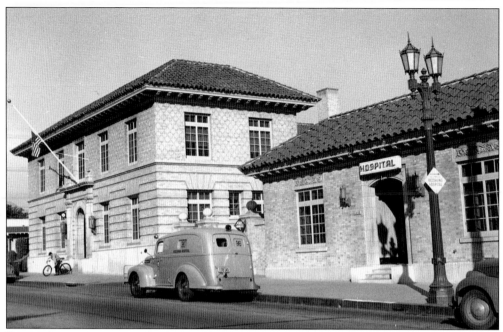

POLICE STATION, 1940. The first Hollywood police force was formed in 1906 in a two-room bungalow in the 1600 block of Cahuenga Boulevard. By 1913, a new police station was built at 1625–1629 North Cahuenga Boulevard. In 1914, the police were joined by the Hollywood Fire Department in a multi-use building on the same site. In 1930, a new Fire and Police Complex was constructed. The police station was located at 1358 North Wilcox Avenue, and the Fire Department at 1327 North Cole Street.

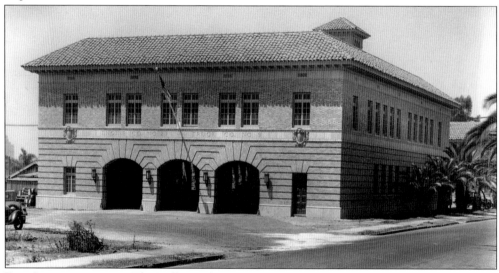

FIRE STATION 27, 1930. The Hollywood Fire Department, after sharing space with the police on Cahuenga Boulevard since 1914, finally got its own building in July 1930, when the new Station 27 Truck Company No. 9 was dedicated at 1327 North Cole Street at De Longpre Avenue. Los Angeles architect P. K. Schabarum designed a two-story, beige brick building with tile roof that was 18,227 square feet. A small emergency hospital was added to the rear of the station on Wilcox Avenue.

Ten

NIGHTCLUBS AND RESTAURANTS

The growth of the film industry brought a proliferation of restaurants and later nightclubs, which contributed to Hollywood's reputation as a party town. The first restaurants were the Six-Mile House and Sackett Hotel. In 1903, the Hollywood Hotel opened with tourist-style restaurant catering for visitors. The Mary Moll Bonnie Brier Hotel in 1913 had its own restaurant, and as more visitors came to Hollywood, the demand for more restaurants became apparent.

The first independent restaurant was John's Café at Hollywood and Cahuenga Boulevards and by 1917 was frequented by film colony celebrities. Just after World War I ended, other restaurants opened on Hollywood Boulevard. The Armstrong Carlton Café, called the "Blue Front," opened in 1919. The Frank's Francois Café, also drawing a movie colony clientele, opened in 1919 as well, and in 1923, it became the famous Musso and Franks Grill.

By the mid-1920s, popular dining spots included the Gotham Delicatessen, Pig'n Whistle Café, Brown Derby, C. C. Brown's Ice Cream Parlor, and Henry's Restaurant, in which Charles Chaplin was an investor. The 1930s included the addition of Al Levy's, Sardi's, Brass Rail, Coco Tree Café, Tick Tock Restaurant, Russian Eagle, the Cinegrill at the Roosevelt Hotel, Cinnebar at the Hollywood Plaza Hotel, Vendome Café, Hofbrau Garden, Nikabob, Don the Beachcomber, Lucey's El Adobe, Bit Of Sweden, Swanee Inn, Brittingham's Radio City, and the Sunset Strip's Marcel Lamaze Restaurant.

After World War I, American culture changed dramatically with a more liberal attitude and a new prosperity, affecting nightlife in Hollywood. By the early 1920s, in keeping with the area's loose enforcement of Prohibition, several nightclubs opened in and around Hollywood Boulevard. The Hollywood Rooftop Ballroom, Blossom Room in the Hollywood Roosevelt Hotel, Montmartre Café, Little Club, Club New Yorker, and by the 1930s the Embassy Club, Florentine Gardens, La Conga on Vine Street, Clara Bow's "It" Café, the Trocadero (which originally opened as La Boheme in 1924), and the Café Mocambo on the Sunset Strip, the Famous Door, Gaslight, Oasis, Carousel, Earl Carroll Vanities, Clover Club, Club Seville, Club Versailles, Century Club, Merry Go Round, Hawaiian Paradise, Bob Brook's Seven Seas, Mike Lyman's, the Tropics, and Ciro's opened by 1940.

The Depression saw nightclubs come and go according to fashion or popularity. Some, like Musso and Franks and the Brown Derby, were clearly established. The Sunset Strip became popular in 1933 with the opening of Maxime's, the first 1930s club-restaurant, and remained so through the Depression years, World War II, and after.

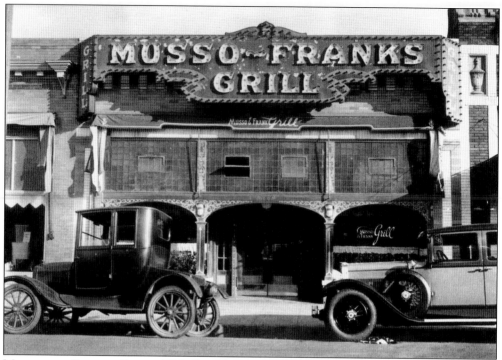

MUSSO AND FRANKS GRILL, 1930. Frank's Francois Café opened on Hollywood Boulevard in 1919. By 1923, it was renamed Musso and Franks Grill. A favorite of the entertainment industry, the restaurant was a favorite of writers and actors, especially since the Writers and Screen Actors Guild had an office across the street. Regulars throughout the 1920s to the 1930s included Tom Mix, Charles Chaplin, Ernest Hemingway, F. Scott Fitzgerald, Lillian Hellman, and Raymond Chandler. Today's celebrity regulars include Drew Barrymore, Johnny Depp, and Keith Richards.

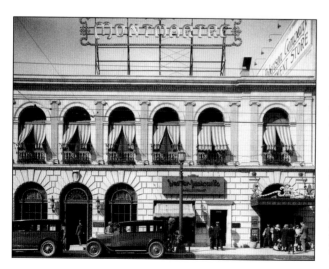

MONTMARTRE CAFÉ, 1929. Located at 6755 Hollywood Boulevard just east of Highland Avenue, this was Hollywood's first major nightclub. Opened on the second floor (the entry was at the lower right corner) in 1923, it had a capacity of over 350. Patrons could join Valentino in the tango or enter the Charleston contest, as young Joan Crawford often did. Singer Bing Crosby made his Hollywood debut here with Paul Whiteman's band.

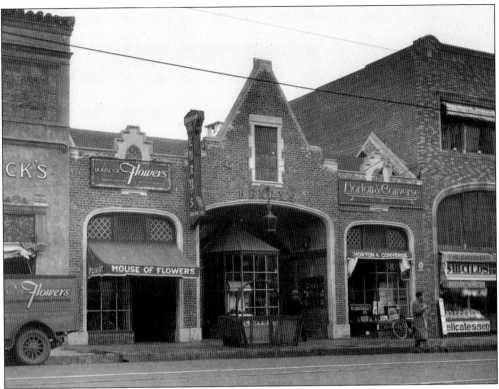

HENRY'S CAFÉ, 1928. Henry's was located in a George Hoover development at 6315 Hollywood Boulevard near Vine Street in an English-style brick building. The restaurant was named after Charles Chaplin's principle player and assistant director Henry Bergman, who managed the place. Financed by Chaplin, the restaurant became a movie colony hangout and a favorite eating place of Al Jolson.

GOTHAM DELICATESSEN, 1937. Located on the first floor of the Sycamore Apartment Building on the southwest corner of Hollywood Boulevard and Sycamore Avenue, this restaurant was Hollywood's first kosher kitchen. Opened in 1924, the Gotham was a favorite of transplanted New Yorkers and Europeans alike. Greta Garbo liked the place because of its informality and good food. During the 1940s, the Gotham often delivered sandwiches to the nearby radio studios.

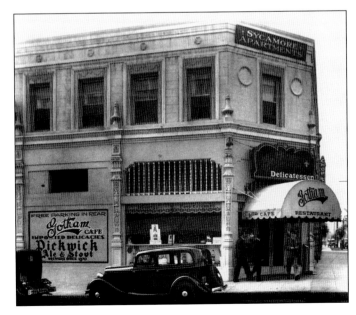

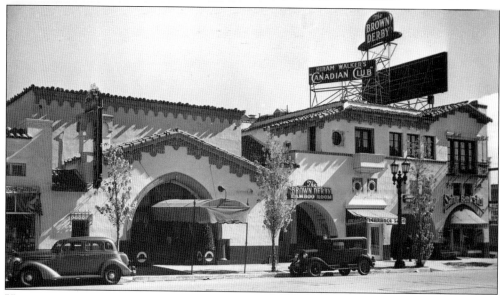

HOLLYWOOD BROWN DERBY, 1937. This was the second Brown Derby after the original derby-shaped one opened in 1926. This one was opened on Valentine's Day in 1929 by owner Herbert Somborn after Jack Warner suggested that the Brown Derby be opened near the studios. Located next to movie studios, radio stations, and theaters, it quickly became a favorite celebrity hangout.

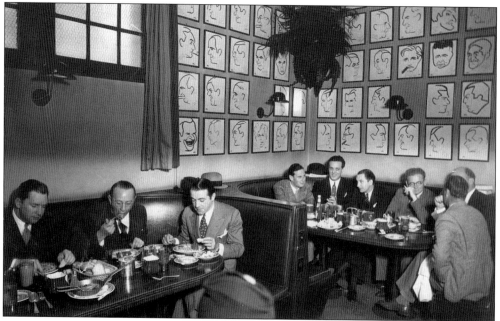

BROWN DERBY, 1939. In 1928, the building for the Hollywood Brown Derby was developed and owned by Cecil B. DeMille. The restaurant interior evolved into the one seen here with the renowned caricatures of the stars on the walls and famous leather booths. Eddie Vitch drew the first caricatures in exchange for meals, and from 1947, the caricatures were created by Jack Lane. Gossip columnist Louella Parsons did her interviews in booths, and regulars ranged from Jack Benny to Katharine Hepburn to Groucho Marx to Howard Hughes.

CARPENTER'S SANDWICHES DRIVE-IN, 1936. This early Hollywood drive-in was part of a chain located throughout Los Angeles. This one was on the northeast corner Sunset Boulevard and Vine Street, where Paramount Studios was located until 1926. By 1938, this restaurant was demolished to make way for the new NBC Radio Studio Center. Carpenter's is briefly seen in the film *Mildred Pierce* (1945) behind Joan Crawford at Mildred's first restaurant job.

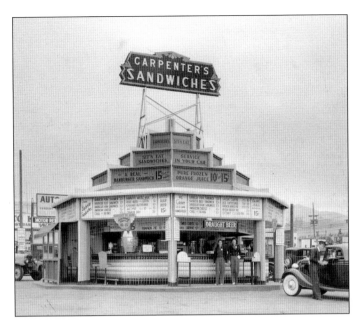

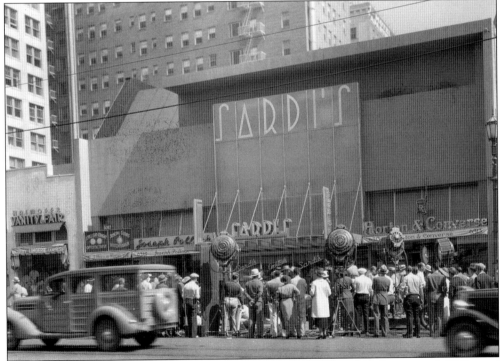

SARDI'S RESTAURANT, 1936. Seen during a location movie shoot for Paramount's *Hollywood Boulevard*, Sardi's was opened in 1932 by Eddie Brandstatter. Its interior and exterior were designed by famed modernist architect Rudolph Schindler, who also created the signage lettering and silverware. Despite the name, and the attempt replicate a New York–style restaurant, Sardi's Hollywood did not have anything to do with the New York Sardi's, which sued unsuccessfully to close this one.

SARDI'S HOLLYWOOD RESTAURANT, 1932. Hollywood celebrity caricatures are seen here on the walls, similar to the rival Brown Derby two blocks away. Some of the caricatures were done by Joe Grant, who became a top character designer and story writer at the Disney Studios (*Fantasia, Dumbo, Beauty and the Beast*, etc.). This was the first site of Tom Breneman's *Breakfast in Hollywood* radio show. Sardi's was a favorite with Maurice Chevalier, Katharine Hepburn, and Marlene Dietrich. In the 1970s, it became the location of the Cave Theater, an X-rated movie house.

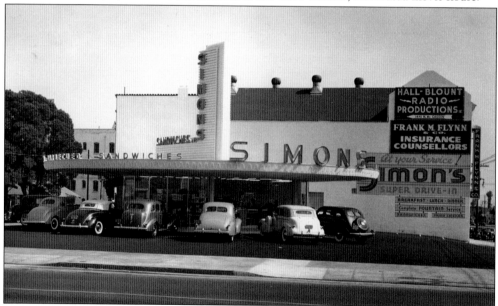

SIMON'S DRIVE-IN, 1939. One of several drive-ins that dotted Sunset Boulevard throughout Hollywood, Simon's was located on the southeast corner of Sunset and Highland Avenue, diagonally across from Hollywood High School. The building behind it was originally constructed as a Moose Lodge and later became a radio broadcast theater and then a recording studio.

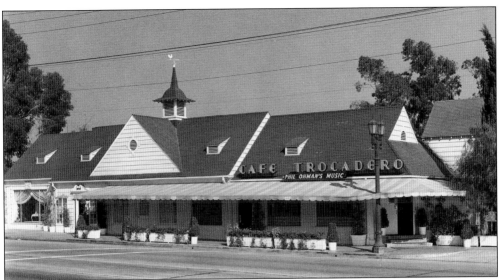

CAFÉ TROCADERO, 1936. The building formerly was a roadhouse known as La Boheme from 1929 until its closure in 1933. The *Hollywood Reporter* owner William "Billy" Wilkerson took it over and opened the Café Trocadero at 8610 Sunset Boulevard on September 17, 1934. The interior was designed by studio art director Harold Grieve as a French-style Café. The Trocadero, very popular through the 1930s, closed in 1946.

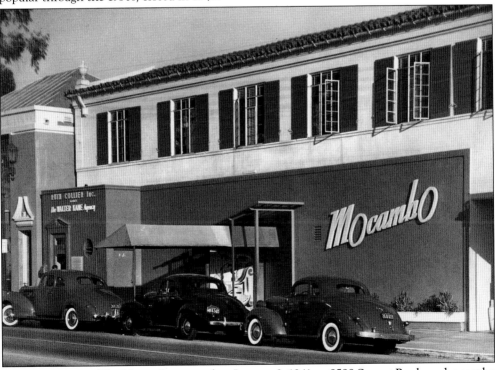

MOCAMBO, 1941. The Mocambo opened on January 3, 1941, at 8588 Sunset Boulevard, near the Trocadero. Owners Felix Young and Charlie Morrison wanted not only a great view of the city for the patrons, but also built a long, glass enclosure where live macaws and other parrots could be viewed from the main room.

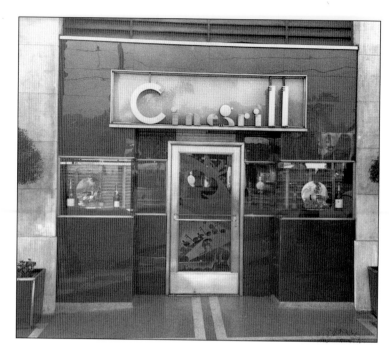

CINEGRILL LOUNGE ENTRANCE, 1935. Located in the Hollywood Roosevelt Hotel, this became one of Hollywood's great nightclubs. It would open and close in various configurations after its 1935 opening, continuing up to 2004, when it was moved downstairs and closed a year after reopening in 2005.

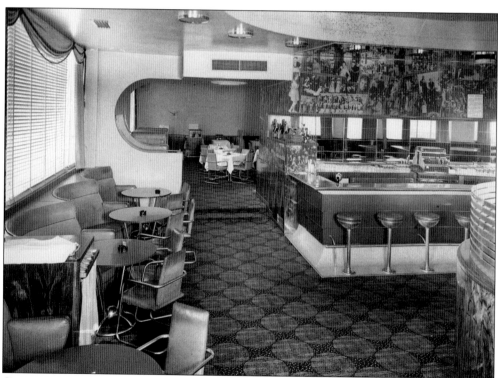

CINEGRILL LOUNGE INTERIOR, 1935. Jazz greats and popular singers, such as crooner Russ Columbo, were Cinegrill performers. Mary Martin sang here while the hotel staff watched over her son, Larry Hagman. Later performers included Etta James, Jimmy Webb, Eartha Kitt, and Cybill Shepherd.

C. C. BROWN'S, 1938.
One of the oldest ice cream parlors in Hollywood was C. C. Brown's, named after Clarence Clifton Brown, who took 20 years to develop his own recipe for a hot fudge sundae. Starting the business in downtown Los Angeles in 1907, Brown sold that store and moved to Hollywood in 1928. From then on, C. C. Brown's became a favorite of actors—from Ronald Reagan to Marlon Brando. Here Joan Crawford and Phil Terry have a hot fudge sundae and a root beer float.

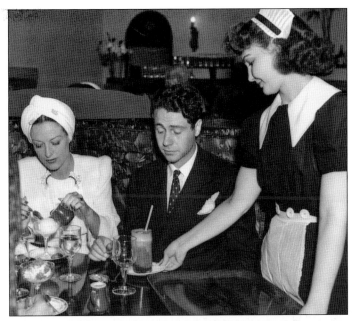

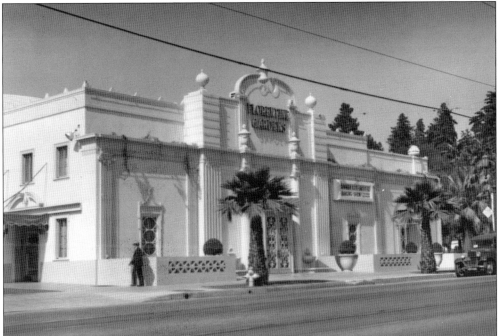

FLORENTINE GARDENS, 1939. Both Florentine Gardens and the Earl Carroll Theater opened in 1938; architect Gordon B. Kaufman designed both theaters. Located at 5955 Hollywood Boulevard, Florentine Gardens was not as elaborate as Earl Carroll but held the same capacity of around 500 people. The stage shows held here were followed by dancing and were popular with tourists and the military during the war. Regular performers included the Paul Whiteman Band, Sophie Tucker, the Ink Spots, the Mills Brothers, Henny Youngman, and a young dancer named Yvonne De Carlo. The legendary "Fats" Waller gave his last performance in the Zebra Lounge, located off the main room.

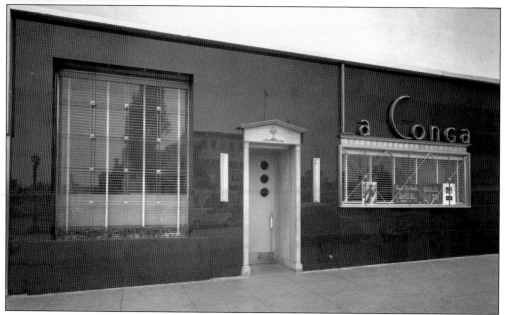

LA CONGA, 1939. When the Rhumba dance craze hit Hollywood in 1937, a new dance club opened at 1551 North Vine Street near Selma Avenue. La Conga was devoted to this dance sensation, and when patrons entered, they were greeted by a talking marionette named "Chiquita," then escorted to their tables.

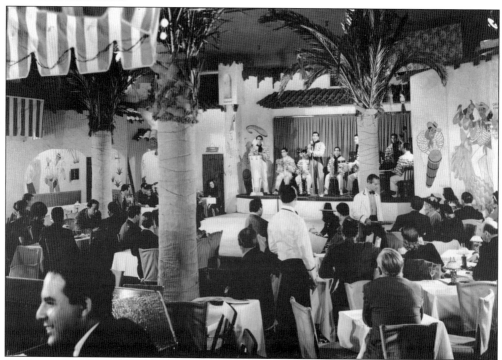

LA CONGA INTERIOR, 1939. The interior was decorated with palm trees, like a movie set version of a Cuban village. The stage was small with a canopy of Spanish tiles and was surrounded with Cuban murals of musicians and dancers in traditional Cuban costume.

IT CAFÉ, 1938. The ballroom of the Hollywood Plaza Hotel on Vine Street had gone through several restaurant/nightclub tenants since the early 1930s. The Russian Eagle Restaurant there was a favorite of actress Marlene Dietrich. After that came the Cinnabar with its photograph collage murals over the bar and finally, after an extensive remodeling, Clara Bow's "It" Café opened in September 1937. It was managed by the silent star and her husband, director Rex Bell.

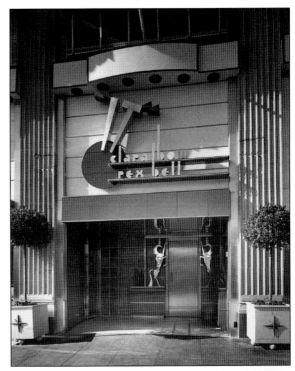

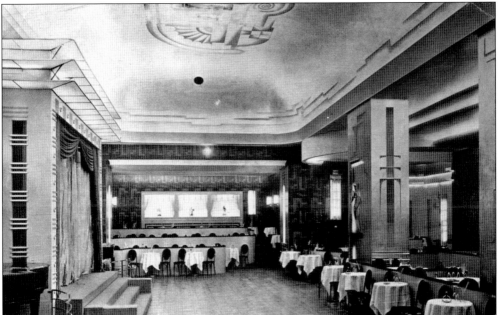

IT CAFÉ INTERIOR, 1938. The interior design was Art Deco from ceiling to floors, which gave the club a feeling of New York style. Co-owner Clara Bow became an overnight movie star at the age of 19 in 1924. With the arrival of sound (she had a thick Brooklyn accent), her career was effectively ended at the age of 25. Looking for something else to do, the "It" Café was a success for her, but she left after a year to spend more time with her son. The café continued on for several more years without her, but her association with it remained a major selling point.

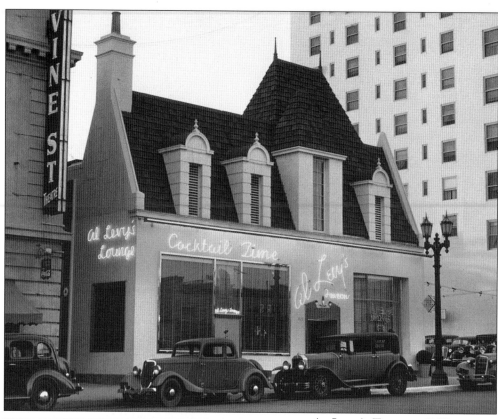

AL LEVY'S TAVERN, 1937.
Located next to the Vine Street
Theater at 1623 North Vine
Street, Al Levy's was one of the
favorite dining places for writers in
Hollywood. After Al Levy retired
in 1940, Mike Lyman, a former
bandleader, owned the place.

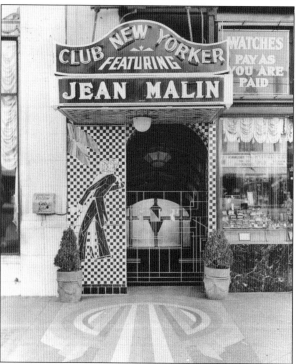

CLUB NEW YORKER, 1930. Actor
Jean Malin opened his Club New
Yorker on the former site of the
Greenwich Village Café. The club
was situated in a basement of a
building adjacent to the Christie
Hotel, with access from the street
by a steep staircase. Marlene
Dietrich and her husband, Joe
Sieber, dined here, and Gloria
Swanson was a frequent visitor.

CLUB NEW YORKER INTERIOR, 1930. Actor Jean Malin, the owner of the Club New Yorker, could be seen nights at the club with his friend and fellow actor Maurice Chevalier. The interior was spectacular in its theatricality and color. A mixture of art nouveau, Art Deco, and Beaux-Arts designs made this small room comfortable but exciting. The small bandstand and dance floor made this nightclub one of the more exclusive hangouts.

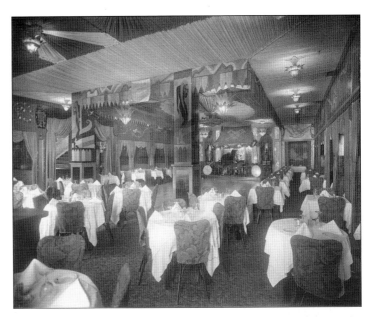

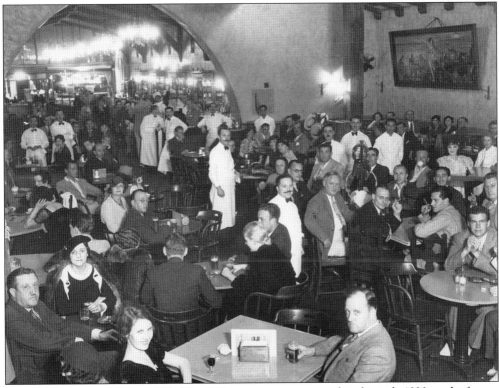

BRASS RAIL RESTAURANT. 1929. This 24-hour restaurant opened in the early 1930s at the former site of Henry's Café on Hollywood Boulevard and seated around 400 patrons. It was especially popular with writers who enjoyed the camaraderie and discussed literary interests. Here is where "Entertaining Waiters" first appeared in Hollywood, who, according to the menu, "leaped to your service one moment and to the stage to amuse you the next."

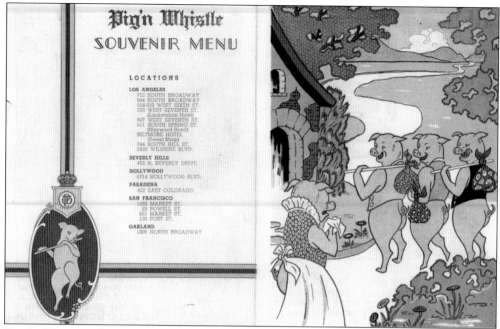

PIG 'N WHISTLE CHILDREN'S MENU, 1935. This chain of restaurants ran from San Diego to Seattle, and several opened in and around the Hollywood area. The flagship was at 6714 Hollywood Boulevard next to Grauman's Egyptian Theater, opening on July 22, 1927. The Pig 'n Whistle was one of the first restaurants to capitalize on image marketing with souvenir menus for adults and children plus coloring books, paper masks, a line of candy, and even a story book explaining where the pigs you were about to have for lunch or dinner came from ("Ever-ever land").

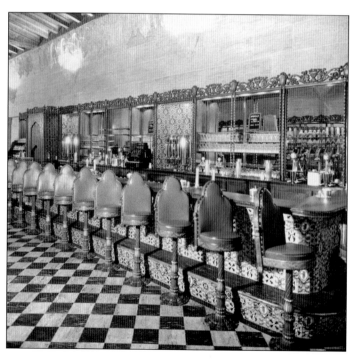

PIG 'N WHISTLE INTERIOR, 1928. This shows the counter of the 6714 Hollywood Boulevard Pig 'n Whistle that remained opened until 1953. Many of the furnishings ended up at nearby Miceli's Restaurant. Owned by Sidney Hodemaker, the restaurant and soda fountain included a small pipe organ in the middle along with elaborate decorations that included custom made Malibu Tiles, seen on the counter with the Pig 'n Whistle logo. A $1 million renovation returned the Pig 'n Whistle for a reopening in 2001.

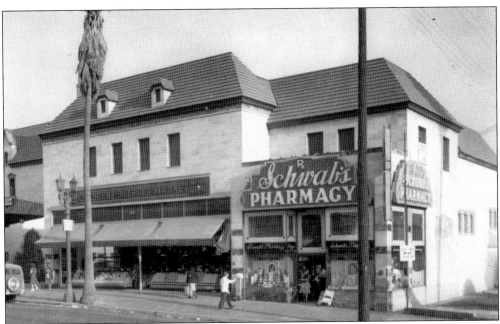

SCHWAB'S PHARMACY, 1938. Schwab's was well-known for its lunch counter, where the management would let movie people eat on credit until their next job came through. It was where composer Harold Arlen was driving by on Sunset Boulevard when he pulled in and sat down to write the music to the song that had just entered his mind—"Somewhere Over the Rainbow" for 1939's *The Wizard of Oz*. Lana Turner was not discovered here, but William Holden and Erich Von Stroheim stopped here in *Sunset Boulevard* (1950).

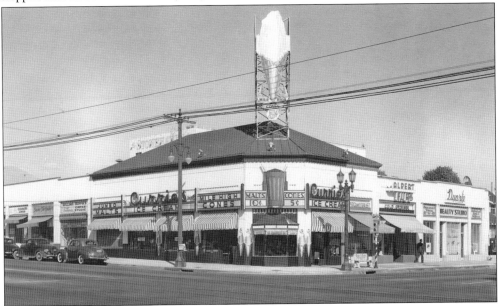

CURRIES ICE CREAM PARLOR, 1939. Located on the northeast corner of Sunset Boulevard and Highland Avenue, the Curries store was one of California chain. This Curries was in a perfect location, across the street from Hollywood High School. The signature roof billboard advertised "Mile High Cones," only 5¢.

www.arcadiapublishing.com

Discover books about the town where you grew up, the cities where your friends and families live, the town where your parents met, or even that retirement spot you've been dreaming about. Our Web site provides history lovers with exclusive deals, advanced notification about new titles, e-mail alerts of author events, and much more.

Find Your Place in History.